IMAGES
*of America*

# KEANSBURG

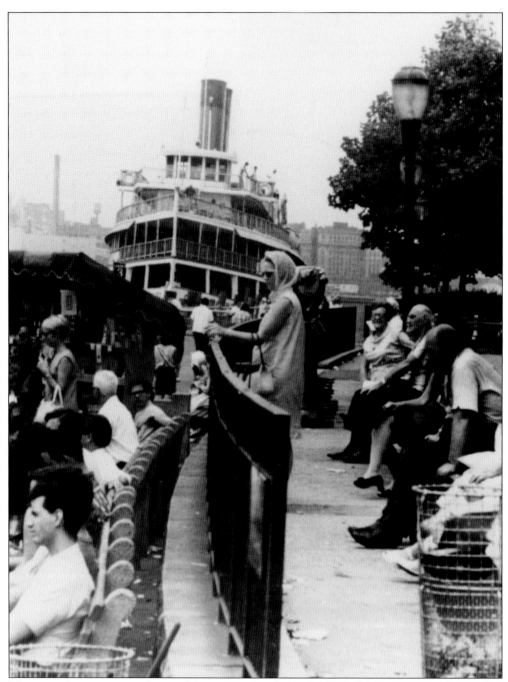

The steamship was a crucial part of the engine that drove the Keansburg amusement-hospitality trade. For many, the day's festivities began with stepping on board, making the ride a major part of the day-tripper's fun. The *City of Keansburg* is seen *c.* 1950s at Battery Park, New York. This book, which hopes to capture the atmosphere of the old waterfront resort, will provide a nostalgic recreation of a trip to old Keansburg.

IMAGES
*of America*

# KEANSBURG

Randall Gabrielan

ARCADIA
PUBLISHING

Published by Arcadia Publishing
Charleston SC, Chicago IL, Portsmouth NH, San Francisco CA

Printed in the United States of America

Library of Congress Catalog Card Number: 2005924549

For all general information contact Arcadia Publishing at:
Telephone 843-853-2070
Fax 843-853-0044
E-mail sales@arcadiapublishing.com
For customer service and orders:
Toll-Free 1-888-313-2665

Visit us on the Internet at www.arcadiapublishing.com

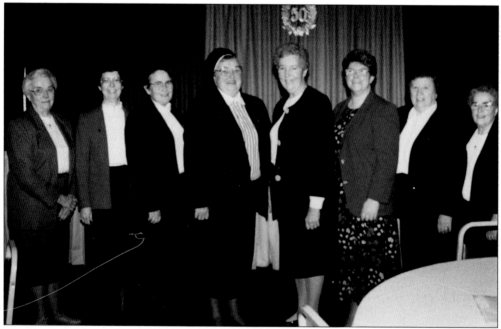

This book is dedicated to the Sisters of Mercy of St. Ann's, whose lives embody the principles of love of God and service to humankind that would serve us all well. They are, from left to right, Emmanuel Victory, Kathleen O'Halloran, Carol Conly, Elizabeth Garvey, Faith Moore, Carol Wilson, Dora McGrath, and Edwardine Brown. I have known the work and missions of three and acknowledge them with special note: Sr. Kathleen O'Halloran of Project PAUL, Sr. Faith Moore of the St. Ann's Child Care Center, and Sr. Edwardine Brown of St. Ann's Hansel & Gretel Preschool.

# Contents

# Acknowledgments

The quality of this book is the product of the care, interest, helpfulness, and generosity of the picture lenders, some of whom also offered their memories and experiences of Keansburg. Several lenders merit special mention.

Henry F. Gehlhaus not only provided many of the finest images, but shared his memories with a buoyancy and enthusiasm that belied his ninety-two years. Paul Hunter, a younger man, carries family tradition from this century's first decade and spoke of it and his memories articulately, with candor and the fondness of a lifelong Keansburg enthusiast.

Collector friends with perpetually open albums provided a vital and productive start for a project that produced an abundance of pictures. My heartfelt thanks to John Rhody and Michael Steinhorn.

Tova Navarra is a skilled writer, artist, and photographer whose *The New Jersey Shore: A Vanishing Splendor* is one of our time's finest New Jersey pictorial works. I thank her for two unpublished images taken during that project.

The Borough of Keansburg history files, little used in recent years, had a pictorial and informational content that made a significant contribution to this volume. My thanks to Tom Cusack and the other borough employees who were helpful during my work there.

Thanks to Photography Unlimited by Dorn's, which is expanding its vintage photograph collection to embrace Red Bank's nearby towns and the shore. Keansburg is well represented in Dorn's holdings.

Special thanks to James Conroy of the W.A. Conroy and Sons Insurance Agency, one of Keansburg's oldest businesses, for the loan of one of my most helpful research resources, the Sanborn *Atlas of Keansburg*.

Thanks to all of the picture lenders: Elizabeth Albert, Olga Boeckel, Lois Bodtmann, Ellen Broander, Millicent Broander, Suzanne Caffery, Roberta Chase, Donald F. Conroy, Ed Cooke of Project PAUL, Joseph Eid, Elizabeth Lloyd Grasso, Scott Longfield, Kathleen McGrath, Sr. Faith Moore, Robert Pelligrini, Helen Pike, Beatrice Van Nortwick, Glenn Vogel, and Edward and Anne Weickel.

# Introduction

Keansburg's history can be divided into three eras: pre-development life on the bayshore, the growth and prosperity of an amusement resort, and the modern era's transformation of the town to a year-round residential community.

The parts of nineteenth-century Raritan (now Hazlet) and Middletown Townships that became Keansburg led a typical waterfront existence of fishing, farming, and shipping. The area was initially known as Waycake, a name of Indian origin with many variant spellings. Other locality references were derived from a physical feature—Point Comfort—and from a maritime activity—Tanners Landing (a dock at the foot of Main Street). The region was later known as Granville, the name of a short-lived 1854-5 post office, and this name was retained until a permanent office was obtained and the town was renamed Keansburg in honor of its postal benefactor (p. 105).

The breadth of the seventeenth-century application of Waycake is elusive and of major historical significance as it is the name of Richard Hartshorne's initial c. 1669 land acquisition. There is no known record of Hartshorne's residency on the land that became Keansburg and no evidence that "Waycake" extended to the Middletown village area around Hartshorne's c. 1670s house.

Captain Andrew J. Wilson, who commanded vessels including the schooner *Jersey Blue*, was the most prominent of the area's mariners. Tanners Landing shipped produce in the summer and exchanged wood and fertilizer in the off season, but had no year-round ship. The area was rich in oysters and was on the menhaden migratory route. Both products were harvested in quantity; a fish-processing plant (which extracted oil from the inedible menhaden, or moss bunker) was built on the shore. Minor commerce was conducted from Hilliards Landing, which was located a short distance to the east on what became Beacon Beach.

Keansburg's first reference in a regional guide likely occurred in the Granville entry in the 1882 *Industries of New Jersey*, where the town was described as a fishing hamlet that had a lighthouse at the point and a population of thirty-five. Although "town father" William W. Ramsay would later claim there were three hundred residents in 1877, his number appears high judging by the number of houses in the area that became Keansburg on the 1873 and 1889 Monmouth County atlases. A Methodist church was founded in 1866, and historian Franklin Ellis, in his 1885 *History of Monmouth County*, indicated a school had been built "many years prior." Much of the shore was marsh; its land was often held in large parcels, with many becoming developed neighborhoods in the early twentieth century. Landowners included the

Wilsons, Seeleys, Carrs, Collinses, and Palmers, among others.

Development was not unknown to Keansburg in the late nineteenth century, prompting a *Monmouth Press* reporter to indicate in 1895 that the town was growing with new houses in every direction. However, the founding of the modern town can be dated to the 1906 organization of the New Point Comfort Beach Company by William A. Gehlhaus and several partners from the Highlands area, and their purchase of a sizable waterfront tract that was renamed New Point Comfort. Their property embraced the shore from a point west of Highland Avenue to another east of Sea View Avenue and covered an irregularly bordered area located well inland.
The New Point Comfort Beach Company mapped their tract for the sale of lots, built facilities to appeal to vacationers, and erected a hotel to accommodate them. Others followed.

The 1911 summer carnival was significant in shaping the Keansburg community. This first annual event ran eight days and succeeded as a major organizational, recreational, promotional, and entertainment affair. A committee embracing several sections of the as yet unincorporated town showed Keansburg could host a major gathering.

A 1910 experience, the denial of a new school for Keansburg, provided lasting memories of the pitfalls of growing towns in rural townships, a lack of local control combined with a reluctance of rural interests to raise taxes to improve declining townscapes. Keansburg, with parts in Raritan and Middletown Townships, had two masters. Many of a now excessive number of small New Jersey boroughs were formed in order for developing areas to raise a few thousand dollars in taxes for local improvements.

The borough movement grew in the early teens, perhaps with the 1913 efforts of board of trade members. The chamber of commerce passed a 1914 resolution in favor of borough organization and the movement was quite active in 1915. The issue gripped the community by the time of the 1917 passage of the borough's incorporation, with most in favor.

Sections of the present Hazlet and Middletown Townships, known as West and East Keansburg respectively, were considered for inclusion in the new borough, but were retained by the townships. Keansburg's borders were adjusted four times, with the 1924 inclusion of the Beacon Beach lighthouse property a notable case as many were not aware this tract, surrounded by the borough, was excepted from the borough law.

This book can not embrace Keansburg's vigorous political history. A lengthy work could be written on its recall elections alone. It will suffice to say Keansburg has changed its form of government twice and operates with the manager-council form under the Faulkner act.

Life on the Raritan Bay shore has been colorful in ways not captured by known pictures. Prohibition rum-running existed throughout the region; it did not end in Keansburg with repeal. A major capture of smuggled alcohol was made in Keansburg in November 1935; the goods were stolen from a Newark warehouse a few months later.

The factors leading to the loss of Keansburg's glitter were common to many resort areas close to cities. Super highways encouraged distant travel. The suburbanization process and an expanding middle class brought many to live near or beyond Keansburg, lessening its appeal as a vacation destination. As Keansburg accommodated itself to year-round residency, small cabins, adequate as summer quarters, became intensively used and many suffered from neglect. A large tract was cleared in a 1960s urban renewal process, with its impact still being felt.

A core of Keansburg's population takes pride of place and are strong advocates of their town. Recent investment in the amusement district is bound to enhance a key element of Keansburg's traditional success. The locale on the water is as appealing now as in 1906. Keansburg may be only a break or two away from a long-awaited rebirth.

The time and space constraints of this first volume meant that some desired images could not be obtained or included. In addition, the dearth of nineteenth-century images was a disappointment. The author hopes buyer receptivity to this book will justify a second volume and looks forward to additional pictures. Please send any information regarding such to 71 Fish Hawk Drive, Middletown, New Jersey, or call 732-671-2645.

# *One*

# Transportation

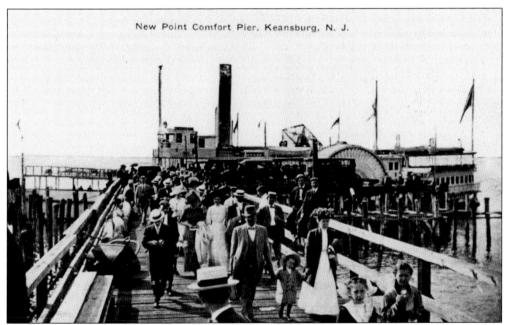

New Point Comfort Pier, Keansburg, N. J.

Prior to the arrival of the automobile, transportation was crucial to the success of a recreation-oriented resort. While trolley companies were building many inland amusement parks, Keansburg's Raritan Bay locale made water-borne traffic the transport of choice. The New Point Comfort Beach Company built a 1,000-foot pier in the spring of 1908; long length was necessary to permit dockage at low tide. It was, in time, extended to over 2,000 feet. The *Keansburg*, seen *c.* 1910 at the dock, was their first owned vessel; it is the renamed *Nantasket*, built in 1878. Note the fancy attire of these new arrivals. (Collection of Michael Steinhorn.)

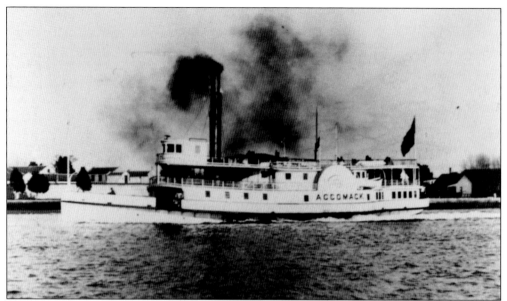

The *Accomak*, chartered *c.* 1907 by Norfolk, Virginia, interests, was the first regularly scheduled New Point Comfort Beach vessel. It reportedly landed passengers by rowboat prior to the completion of the dock. The New Point Comfort Beach Company investors incorporated the Keansburg Steamboat Company in 1910, reflecting the growing importance of maritime operations, organizing what would be locally known as the "Gehlhaus Navy." (Gehlhaus Archives.)

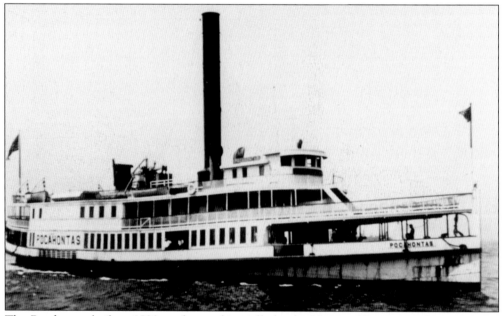

The *Pocahontas*, built *c.* 1890s and owned initially by the Virginia Navigation Company, was bought for an estimated $75,000 from the Old Dominion Lines in Virginia *c.* 1920. Henry Gehlhaus recalls the vessel had been a day boat running an inland route from Richmond to Norfolk, carrying passengers and freight, making twenty-four stops en route. The ship was dismantled at Keyport in 1939. (Gehlhaus Archives.)

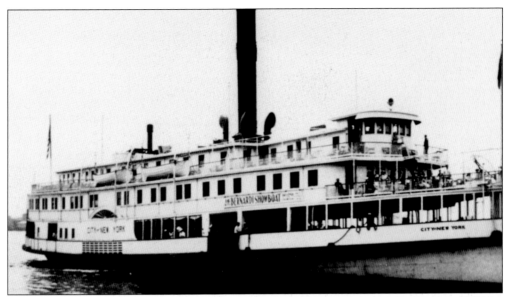

Henry Gehlhaus recalls buying the surplus *Talbot* from the Pennsylvania Railroad in 1937 for $5,000, spending an additional $10,000 for remodeling, and renaming the vessel the *City of New York*. Henry and a crew went south to secure the boat. They were caught in a storm off Atlantic City and were detained by the Coast Guard, who cited the absence of a certificate. Although Henry pointed out a buyer of a vessel had the right to take it home, the Coast Guard was reluctant to yield. Torn from winter storage in Keyport by an early 1950s hurricane, the vessel was scrapped at the inland spot where the storm left her. (Gehlhaus Archives.)

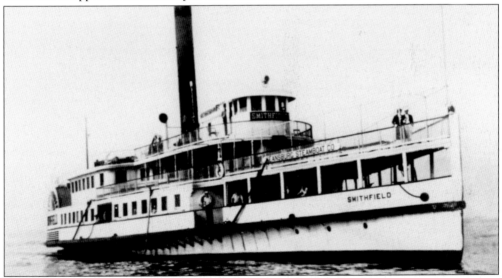

The *Smithfield*, built in 1901 and lengthened in 1908, was initially named the *Hampton*. It was a second c. 1920 acquisition from the Old Dominion Lines, bought for an estimated $75,000. It was licensed for inland sailing, and had run a Virginia route (Smithfield-to-Norfolk), serving as a feeder for boats sailing to New York City. The ship was out of service by 1940 and had been tied up at Keyport, where it broke loose in the 1944 hurricane and was blown on top of the wreck of another vessel. The *Smithfield* was cut up for scrap in the winter of 1947-8. (Gehlhaus Archives.)

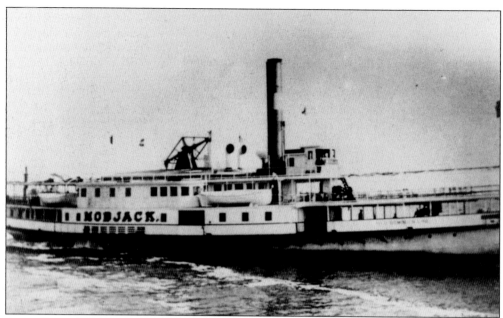

A recalling of the c. 1922 purchase of the *Mobjack* from the Old Dominion Lines stimulated fond memories from Henry Gehlhaus. He took a crew via rail to Virginia and sailed the vessel home; it was his first ocean trip. The $50,000 acquisition had run the Mobjack Bay-to-Norfolk route. It fell victim to poor maintenance and, along with the *Pocahontas*, was dismantled at Keyport in 1939. (Gehlhaus Archives.)

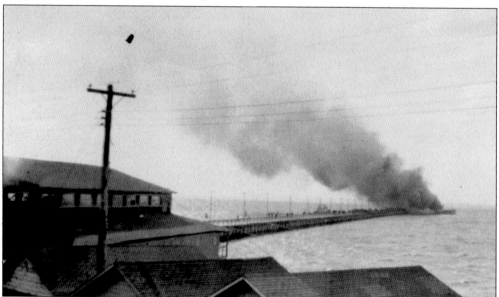

Fire broke out on the Keansburg Steamboat Company pier on Sunday, May 13, 1928, after the *Smithfield* sailed shortly after 4:00 pm. The blaze raged for five hours, destroying around 250 feet of the end of the pier. Numerous fire companies were called, while Coast Guard cutters and the *Smithfield* fought the fire from the water. Nurses were summoned to assist firemen overcome by smoke. The fire was out by about 9:00 pm, but small fires erupted that had to be extinguished throughout the night. The damage was recovered. (Borough of Keansburg.)

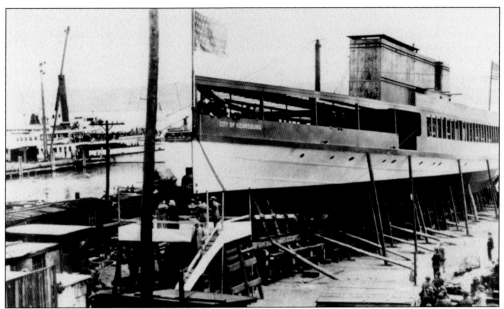

The *Keansburg* burned early in 1926 while in storage at the Harry A. Marvel shipyard in New York, the site where a second vessel of similar name, the *City of Keansburg*, was being built. Discussion over the size of the new boat occasioned early investor Jesse L. Sculthorpe to sell his interest to William A. Gehlhaus. The new vessel, seen at its May 27, 1926 launching, was completed that year. The 250-foot ship, with two sets of 750-horsepower, 3-cylinder engines, could carry two thousand passengers and became the pride of the fleet. (Gehlhaus Archives.)

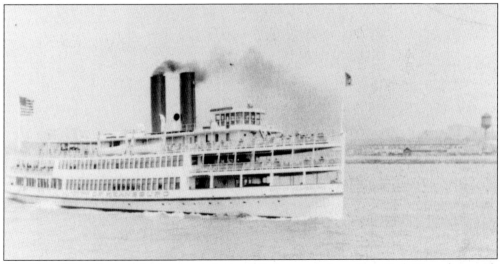

The *City of Keansburg* made three round trips daily in season from New York City, along with short excursions that featured dancing to live music. Storms had long plagued the Keansburg pier, and its destruction in the 1962 hurricane effectively ended the New York-Keansburg run. Plans to use piers at Sandy Hook or Atlantic Highlands were refused or unsuccessful; the latter's pier burned in 1965. The *City of Keansburg* attempted sightseeing trips and took traffic to Monmouth Park for a couple of years, but it ceased operations after the 1968 season and was sold in 1971. A later owner towed the craft to Florida, where it now lies in a marine graveyard. (Gehlhaus Archives.)

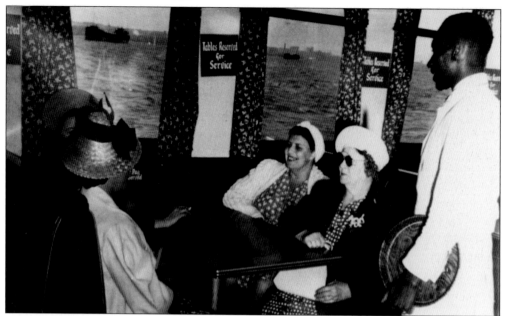

The *City of Keansburg* was designed to serve food. Light meals and beverages were provided during its entire run. This image appears to have been taken around the 1940s. (Gehlhaus Archives.)

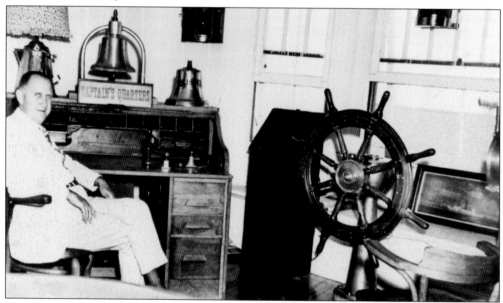

Henry F. Gehlhaus, born 1905 and a 1928 graduate of Temple, is seen in his office with its nautical decor in 1968. He worked his way to the captain's rank, having served in the firm's maritime operations in many capacities. Henry assumed the presidency of the real estate and shipping firms upon the 1950 death of his father. Henry was a director of the Keansburg National Bank and its successor organizations, continuing as a member of the board of advisors of CoreStates Bank. He lives in Middletown with his wife, the former Janet E. Kobayash. Henry is also pictured with his two sons on p. 48. He remains president of New Point Comfort Beach Company, now a holding company. (Gehlhaus Archives.)

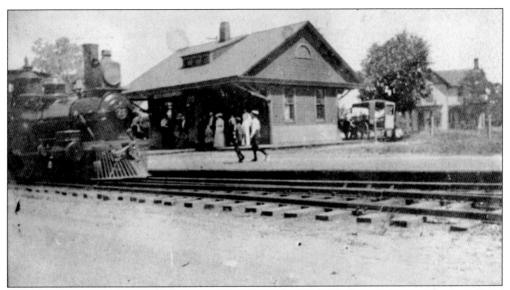

The railroad reached Keansburg in 1892, when the New York and Long Branch line at Matawan was connected to Atlantic Highlands, a station attaining new prominence when the Central Railroad steamer pier was relocated from Sandy Hook to that town. This locomotive, No. 77, named the Penobscot, was built by the Baldwin Locomotive Works, and is seen here *c.* late 1890s in Keansburg.

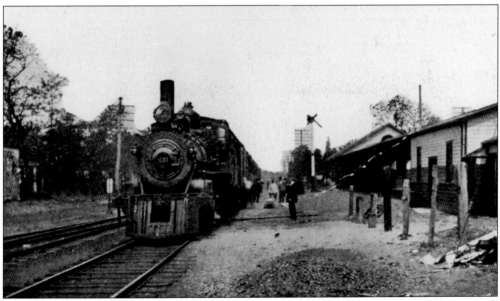

The Keansburg station was expanded more than once, as shown in this *c.* 1910 postcard. Borough interests, dissatisfied with rail service on the Atlantic Highlands branch, attempted in 1928 to secure a connection with the main New York and Long Branch line at a point between Hazlet and Middletown. Their efforts failed. The Keansburg station, located on the south side of Church Street east of Creek Road, at a spot now in the parking lot of Jackie Keelen's, was demolished. (Collection of John Rhody.)

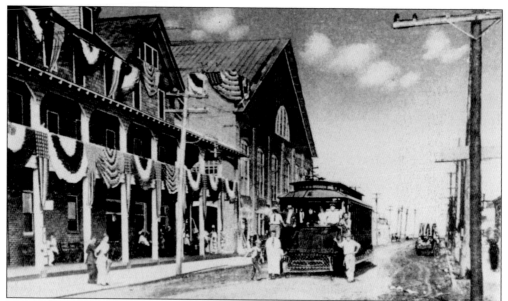

The Jersey Central Traction Company's Keansburg spur was a summer-service, single-track line that ran along Carr Avenue, beginning at the Central Railroad's tracks south of Church Street. The main trolley line was south of the railroad, which did not permit a grade crossing. A siding at Seeley Avenue permitted cars running in opposing directions to pass. This trolley spur began operations on July 22, 1914. This image is a *c.* 1915 postcard showing a car traveling on the brief stem west from Carr to the Keansburg Steamboat Company pier. (Collection of John Rhody.)

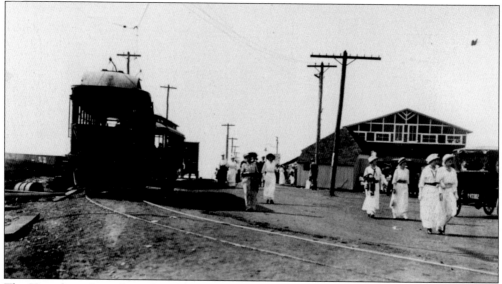

The Keansburg Steamboat Company, the driving force behind the trolley spur, subsidized its operations and widened the pier for the laying of tracks to its end. The lack of permanent facilities or connections north of the railroad resulted in the use of temporary connections to move cars to Jersey Central Traction's regular line at the beginning or the end of the service season. Cars were serviced on the street. The Keansburg spur operated until 1921. (Collection of Joseph Eid.)

16

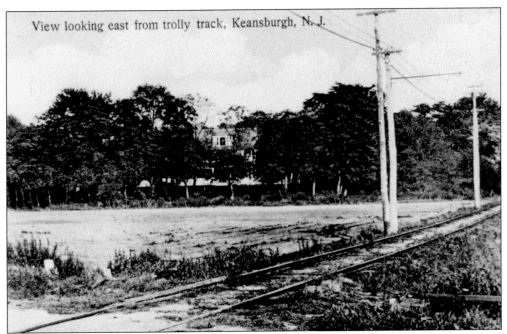

View looking east from trolly track, Keansburgh, N. J.

Keansburg was a stop on the Jersey Central Traction Company's Keyport-to-Red Bank route. Service began in 1904, prior to Keansburg's period of rapid development. The trolley tracks ran parallel to the Central Railroad through Keansburg. This view looks east from an unspecified spot, although a clearer view of the building in the background would provide identification. (Collection of Michael Steinhorn.)

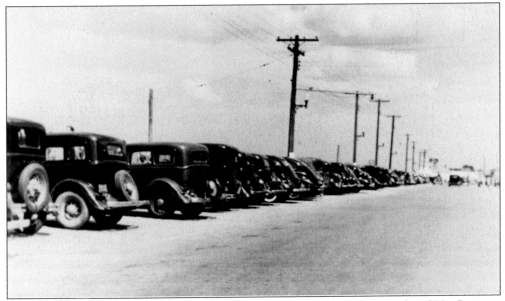

Cars jammed borough streets when private motoring became prevalent in the 1920s. Property owners with a few spare square feet could become parking-lot entrepreneurs. The exact locale of this c. late 1930s scene is unknown, but it is possibly Beachway. (Gehlhaus Archives.)

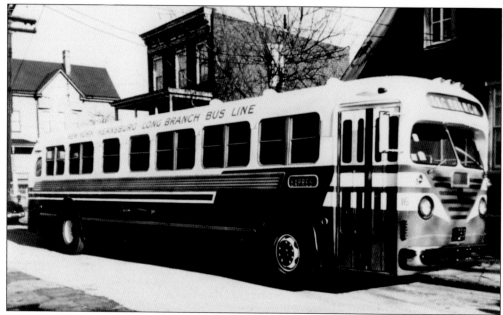

Henry Gehlhaus foresaw the expanded role of motor transport to New York prior to World War II, but his early request for operating authority was denied, as the I.C.C. claimed Keansburg was too small for a year-round operation. A later, better-prepared application was accepted and resulted in the beginning of the Keansburg-New York-Long Branch Bus Line on July 5, 1950. This coach was photographed in 1958; Gehlhaus sold the line in 1968. A successor, Academy Lines, runs a heavily trafficked commuter operation on the route. (Gehlhaus Archives.)

The Narrows between Brooklyn and Staten Island, through which the steamers passed, was spanned in 1964. The bridge enhanced and quickened automobile travel between the New Jersey shore and Brooklyn, and the eastern Long Island counties. However, motorists had already demonstrated with the 1950s opening of New Jersey's superhighways that "farther" was another travel quality embraced by the contemporary driver. The older resorts entered or continued their states of decline.

# Two

# A Place for Fun

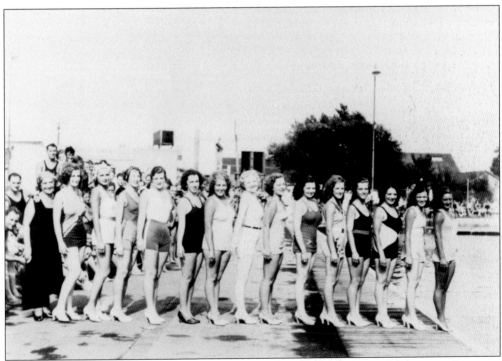

The beauty contest at the August Carnival was a staple of the Keansburg event for years. Although the names of the 1932 contestants are elusive (although one or more always surfaces after publication), an opportunity is presented the viewer—pick the winner (unless you have seen p. 31 already). The women struck the author with their pleasing "girl-next-door" quality, as it seems that anyone could enter and be in the running. (Gehlhaus Archives.)

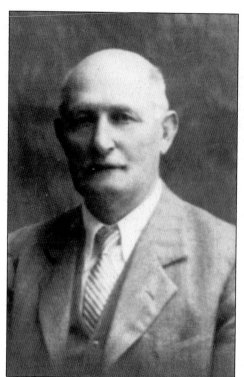

William Alvin Gehlhaus, born in 1871 at Matawan, began his business career in his father Charles' bakery and brickyards. His purchase of Keansburg land in 1906 with partners from Highlands, whom he eventually bought out, began the transformation of an under-utilized, marshy stem of the Raritan bayshore to an active, thriving resort. He operated the Keansburg Steamboat Company under the style of the New Point Comfort Beach Company, a still-existing firm, also organizing in 1908. Gehlhaus was an organizer of the Keansburg National Bank and the Keansburg Building and Loan Association. He married Lillian Newman in 1898; Lillian died in 1900 and he married Isabel Smith in 1903. Gehlhaus died in 1950 and is survived by his two children of his second marriage, Henry (p. 14) and Lillian. (Gehlhaus Archives.)

Carr Avenue, seen looking south at Beachway in 1912, seems very bright as the time exposure adds an aura around the small street lamps. Although the three youngsters in the foreground appear to have remained reasonably still, the blurred subjects in the rear moved. (Gehlhaus Archives.)

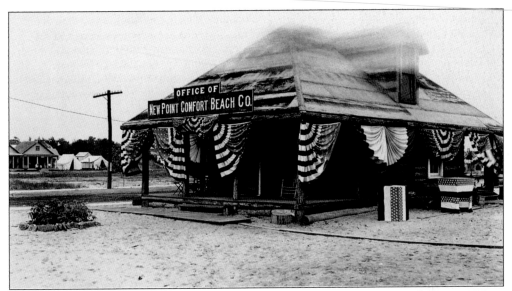

William A. Gehlhaus built a combined log cabin real estate office and dwelling in 1906 on Beachway at the foot of Carr Avenue. The offices were moved to Carr Avenue in January 1914, with the log cabin later moved near the pier. The "drug store" building (p. 89) was then erected where the cabin stood. The log cabin, later quarters for summer hotel employees, was destroyed in March 1917 by a fire that began as burning grass. This c. 1910 image looks south, with cabins and tents on Bay Avenue visible in the distance. (Gehlhaus Archives.)

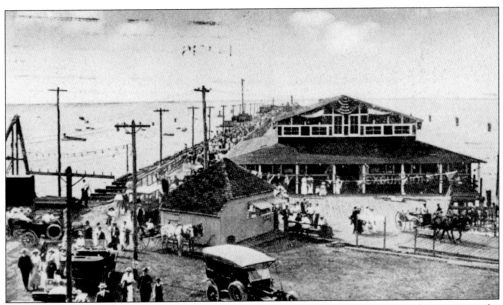

A busy Keansburg Steamboat Company pier is seen c. 1920s. Workers on the pier may be removing the trolley tracks. The train ride had not yet been installed. The large building, now the site of a bar, appears to be the former dance hall, apparently moved from Beachway when the auditorium was built. The steamer pier, destroyed by a hurricane in 1962, is now the site of the 1986 "fishing pier."

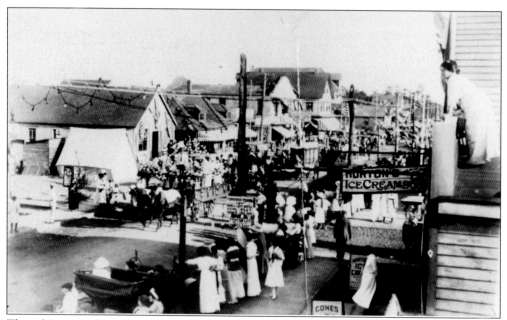

The subject at right gazes east along Beachway, while the reader's eye is drawn south along Carr Avenue in this 1913 image. A brick store, now an arcade, occupies the spot where she stands, while a restaurant is now on the opposite corner. (Gehlhaus Archives.)

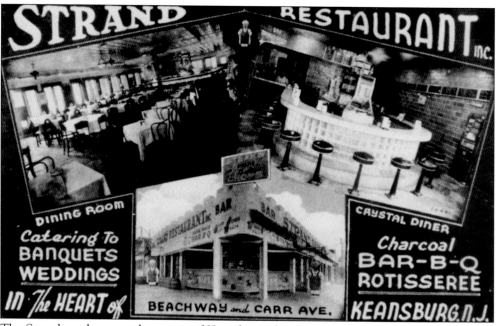

The Strand was long popular as one of Keansburg's finer restaurants. Located at the corner of Beachway and Carr Avenue, it is seen in a c. 1940s postcard. A new restaurant opened in 1997 on the site. (Collection of John Rhody.)

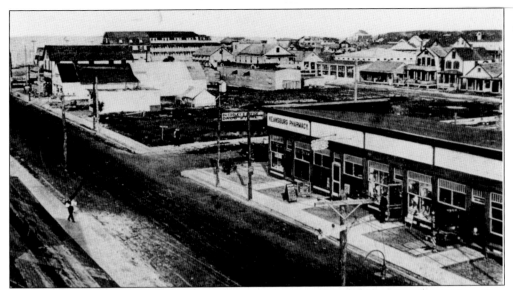

This *c.* 1912 postcard view from the New Point Comfort Hotel on Beachway provides a fine perspective of a growing amusement district. The foot of Carr Avenue is at left, with the rooflines of its commercial buildings visible across the image. The hotels of the eastern stem of Beachway are in the left background, while the smaller rooming houses and cabins on the side streets are in the right background. (Collection of John Rhody.)

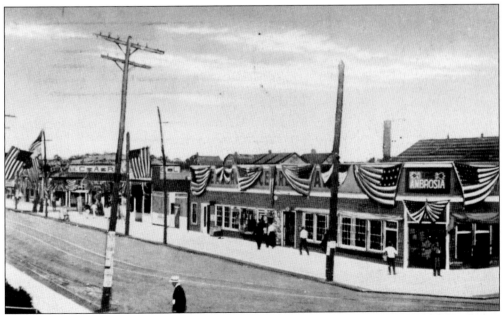

The Ambrosia restaurant was located at the southwest corner of Carr Avenue and Beachway. This *c.* 1920 image shows the trolley tracks that turned west on Beachway to approach the pier (p. 16). Paul Hunter recalls being told how a fine restaurant foundered during the difficult times of Prohibition. An arcade is on the site now. (Collection of John Rhody.)

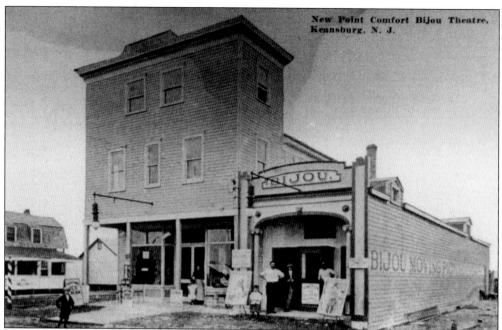

The store and theater on the east side of Carr Avenue viewed *c.* 1908 almost appear to be temporary buildings. (Collection of John Rhody.)

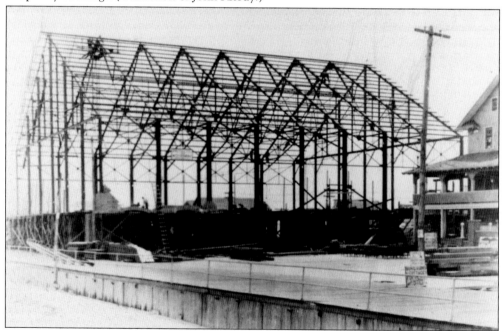

The New Point Comfort Auditorium was built *c.* 1915 adjacent to the east side of the New Point Comfort Hotel, seen at right. The building was originally a dance hall, having been built on the site of the 1910 dance hall (p. 50), which appears to have been relocated near the pier. A later dance hall featuring the Crystal Ball Room was built *c.* 1917, resulting in additional occupancies for the auditorium, which later included a skating rink, bowling alley, and arcade. See p. 16 for the completed building. (Gehlhaus Archives.)

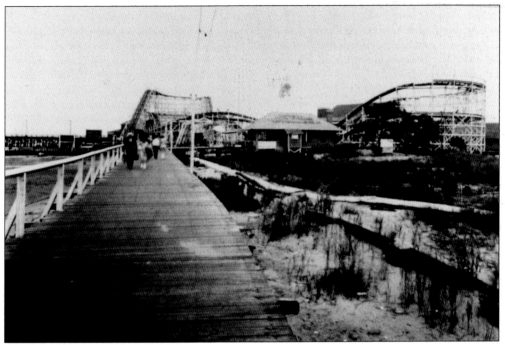

The New Point Comfort roller coaster is viewed *c.* 1926 from the boardwalk west of the pier. The ride, known as the Jack Rabbit, an old generic name for roller coasters, did not fit on the land north of the street and so it was built over the roadway. (Gehlhaus Archives.)

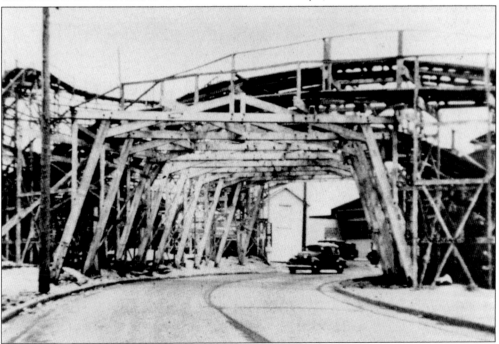

Beachway curves sharply to the southwest at the former point of the Jack Rabbit cut-through, seen here *c.* 1940. The ride was demolished years ago; smaller rides and games are on the site now. (Borough of Keansburg.)

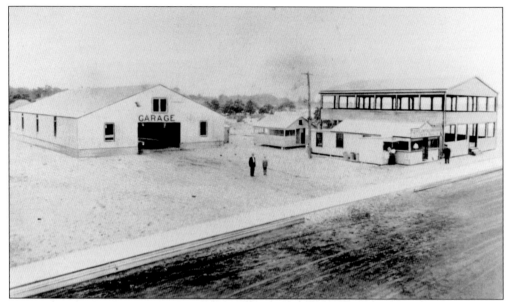

Contractor Frank Johnson built this 60-by-100-foot sheet-metal garage opposite the New Point Comfort Hotel in May 1911. This image appears to date from shortly after completion. The Point Comfort Shore House Ice Cream Parlor is the lower building at right. The two-story structure, later enclosed by shuttered walls, operated as Camp Raritan, renting "semi-outdoor" rooms. The garage was demolished c. 1928 for construction of the Crystal Pool, while Camp Raritan was taken down c. 1990s.

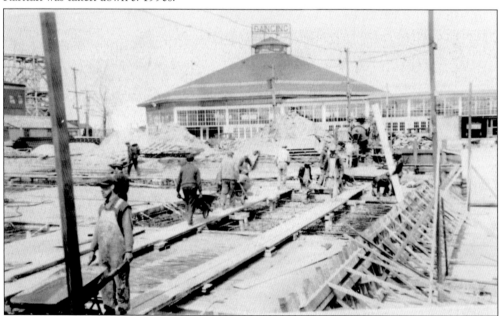

Henry Gehlhaus recalls the Crystal Pool project beginning in 1928, ". . . the first winter I was not in school." This construction scene provides a fine view of the Crystal Ball Room, an octagonal building moved to Keansburg from the 1926 Philadelphia Exposition. The building was destroyed by fire in the early 1980s, while the pool was removed for the Runaway Rapids water park in 1995. Note the Jack Rabbit at left. (Gehlhaus Archives.)

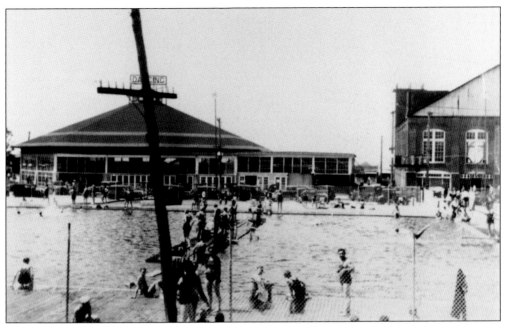

The *Register* described the Crystal Pool as it neared completion in March 1930 as 100-by-150 feet, with a depth grading from 3 to 9 feet. Its over 600,000 gallons of water would be supplied from the bay; its filters would be more than 350 feet from shore. The pool's drainage system was located about 1,000 feet from its source of supply to prevent contamination. Lights, both above-ground and in the pool, would permit swimming at all hours. This view is *c.* early 1930s. (Gehlhaus Archives.)

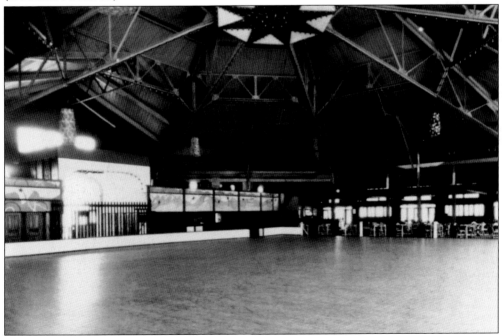

The center chandelier was an interior distinction of the Crystal Ball Room. This image is likely *c.* 1930s, a time when marathon dances were held here. (Gehlhaus Archives.)

The newly organized borough passed a series of ordinances in 1917, including number 7, which prohibited the wearing in public of bathing suits known as "one-piece bathing suits" or other immodest or indecent bathing suits. The borough was wary of undue exposure. This unidentified bather photographed some years earlier, however, demonstrated, perhaps unintentionally, that a well-covered bather can be suggestive despite an excess of fabric.

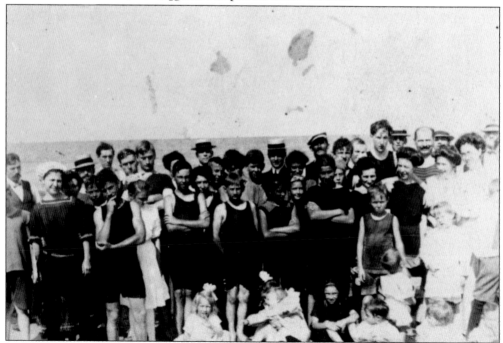

A cheerful, if unidentified, group provides a good showing of early-century bathing attire on the beach at Keansburg. (Gehlhaus Archives.)

Tova Navarra is well known today as a writer, artist, and photographer, but confesses to having been a confirmed beach buff as a youngster. Keansburg was a favorite destination from the family's Essex County home. Tova is seen here c. 1955 with her brother, Gregory Treihart.

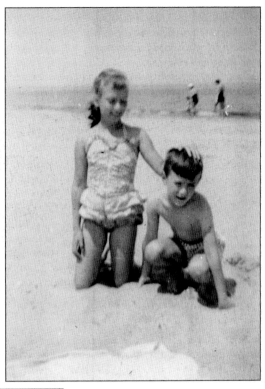

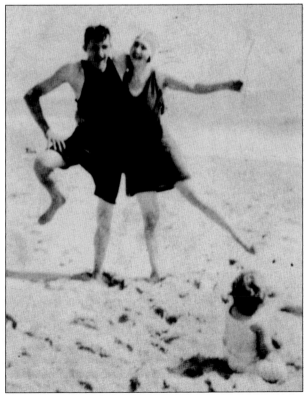

Lillian and Arch Moore, shown with their son John in 1924, found the beach a pleasant spot for impromptu fun. Plainfield residents were regular visitors to a family member's bungalow through 1927. The picture was lent by daughter Sr. Faith Moore, a member of the Religious Sisters of Mercy (p. 4), whose present calling in Keansburg is director of St. Ann's Child Care Center.

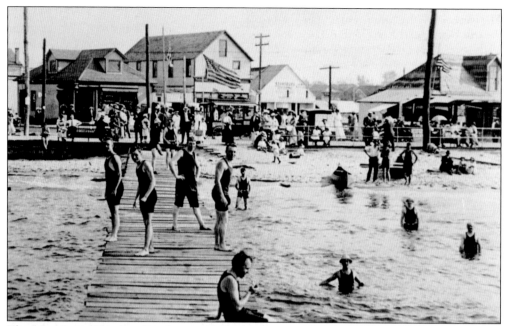

The New Point Comfort Beach east of Carr Avenue is seen *c.* 1915. Today amusements are along the street and the paved boardwalk. (Gehlhaus Archives.)

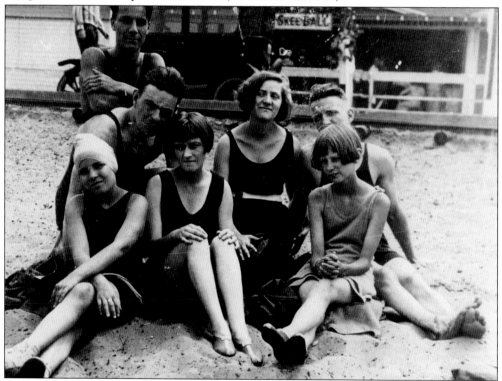

Mary Tully, grandmother of the lender Paul C. Hunter, is posed with a family group on the beach *c.* 1930. They do not appear happy. Is it discomfort over being photographed, or the realization that they are sticky with sand and broiling in the sun?

The winner was the fifth woman from the left. Perhaps her slight pout on p. 19 does not convey a typical first-place bearing, but she appears much more agreeable with the trophy in hand. The lifeguard at left is certainly impressed. (Gehlhaus Archives.)

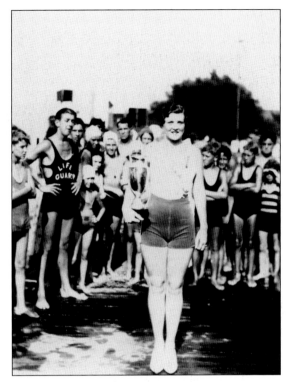

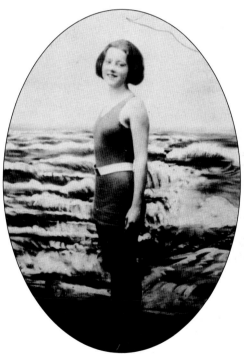

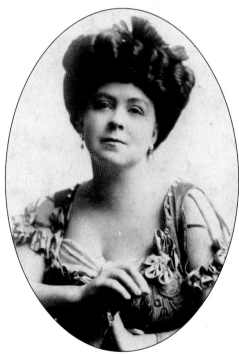

Attractive females have long graced Keansburg, including the unnamed girl in front of an ocean backdrop (left) and Kate Carlton, identified only by name. The images date from earlier in this century. (Gehlhaus Archives.)

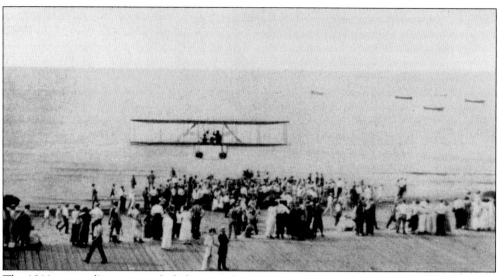

The 1911 carnival's events included an aerial exhibition by O.G. Simmons and his hydroplane. Say, is he not getting dangerously close to the crowd? He avoided mishap that year, but look below.

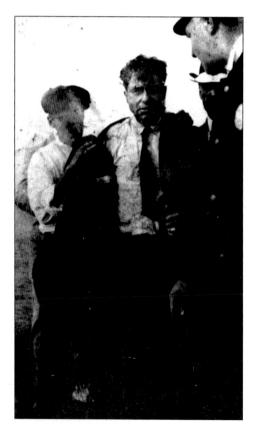

Elizabeth Albert, a niece of local sportsman Del Fisher, found in the family photograph archives a rare picture of the aftermath of a plane crash following the 1912 carnival. Del Fisher is seen placing a coat on Jim Hubbard, as Arthur Sickles and a police chief look on. Hubbard, a passenger with Simmons, sustained head injuries after their plane dropped 200 feet into Raritan Bay. Simmons was unhurt, but his plane was wrecked.

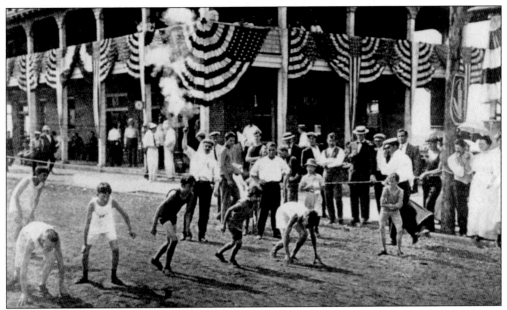

The boys' quarter-mile race at the 1911 carnival began on Beachway in front of the New Point Comfort Hotel.

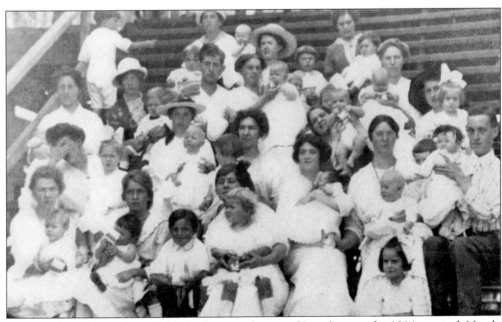

You must have been a beautiful baby, because the crowd loved you at the 1914 carnival. Nearly one thousand babies were in line for the parade. Prizes were awarded for several categories.

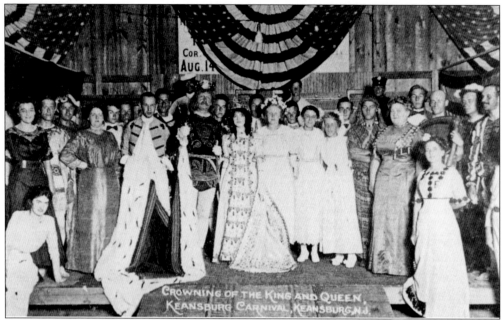

The king and queen of the 1911 carnival were selected by popular vote. Genevieve McSherry, granddaughter of Luke McSherry (whose house is on p. 127), was chosen queen by a wide margin. The king, A.W. Lucas, was old enough to be her father, said one press account. But, so what; royal marriages are often like that. How about their courtiers? Can you find among them a queen mother, evil step-sister, joker, and pretender to the throne? The author has. (Collection of John Rhody.)

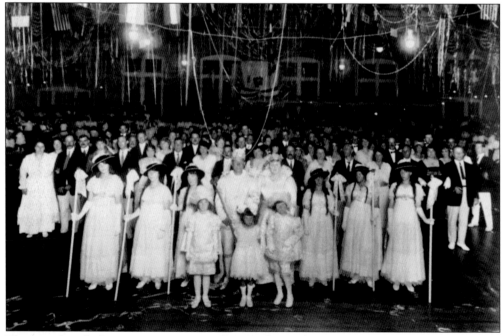

This unidentified event appears to have taken place in the c. 1915 auditorium. (Gehlhaus Archives.)

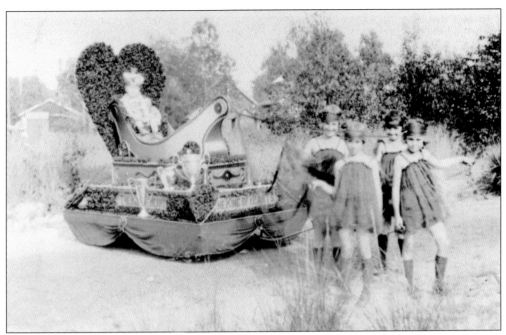

The King of Hearts had an elaborate carriage at this unidentified carnival. The Queen of Hearts missed this photo op as she was reportedly home baking some tarts. (Gehlhaus Archives.)

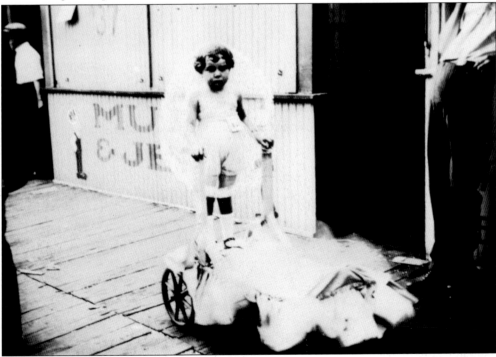

The girl is a little cutie and the crowd undoubtedly adored her, but this failed to mitigate her distress as she was wheeled through the town's less sightly scenes. Children undergoing the stress of competitions for the gratification of their parents has been in the news in 1997, and things appear not to have been different for this unnamed miss c. 1920. (Gehlhaus Archives.)

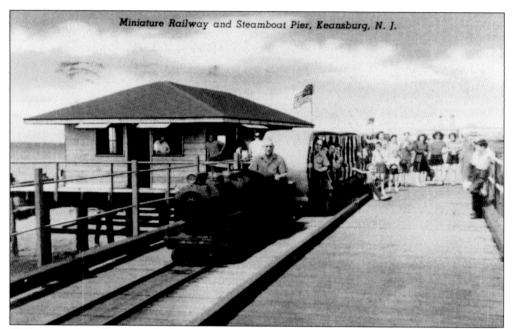

*Miniature Railway and Steamboat Pier, Keansburg, N. J.*

The miniature railway was built on the pier *c.* 1920s and operated until the September 1960 storm known as Hurricane Donna hit the area. The stand is probably the one built by Daniel Seeley in 1911 as a bait and fish house. It was halfway out on the pier, a locale a news account called the best fishing spot. (Collection of John Rhody.)

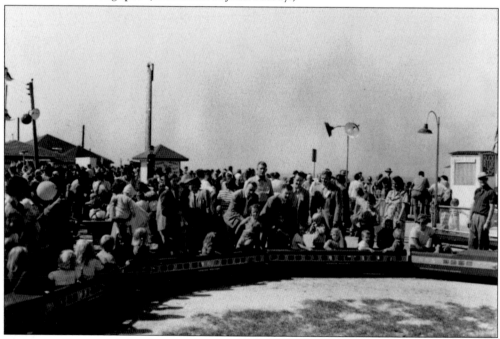

The train ride not only has been at the same location on the north side of Beachway opposite Raritan Avenue since its 1940s installation, but also uses the original equipment! This image is from 1949; the train is painted purple in 1997, carrying the name of the Atlantic Coast Line. (The Dorn's Collection.)

36

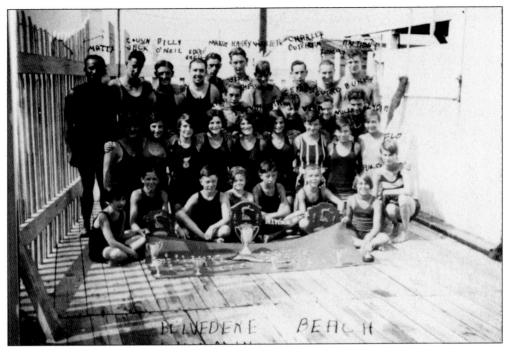

The Belvedere Beach Swim Team c. 1930 seemed quite skillful, judging by their medals and trophies.

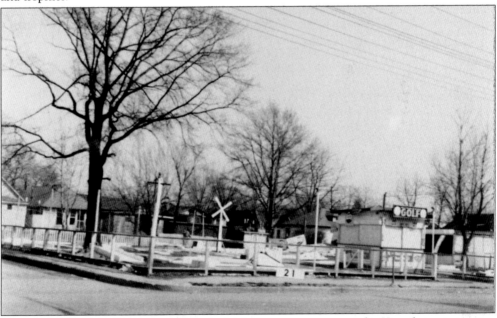

Miniature golf, better associated with the highway, was present on the Keansburg streetscape at the southeast corner of Carr Avenue and Oak Street. Built in the 1950s by James Napolio, the facility featured a number of entertainments for youths, with whom it was popular. The course was short-lived, as its owner preferred a year-round business. Napolio gave up the course to open Nappy's General Store on Carr Avenue (p. 121), which is still run by his son James. (Borough of Keansburg.)

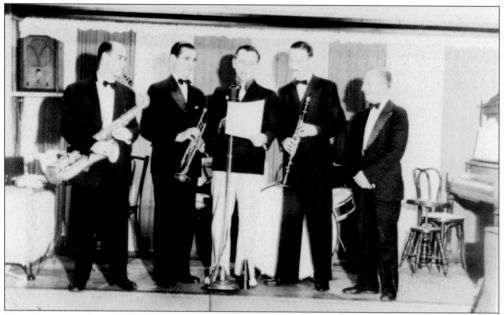

Keansburg's nighttime entertainment long featured live music and dancing. This image of Herb Shea's appearance was not dated, but the locale is likely the Crystal Ball Room. (Gehlhaus Archives.)

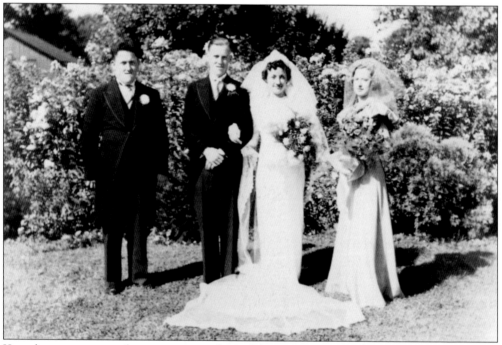

Keansburg was a great place to meet members of the opposite sex, with numerous marriages the product of summer encounters here. The bride and groom in this c. 1930s image are unknown, but their smiling countenances (unshared by their attendants) are representative of the Keansburg marriage. The site is likely the orchard once off Carr Avenue, as recalled by Henry Gehlhaus. (Gehlhaus Archives.)

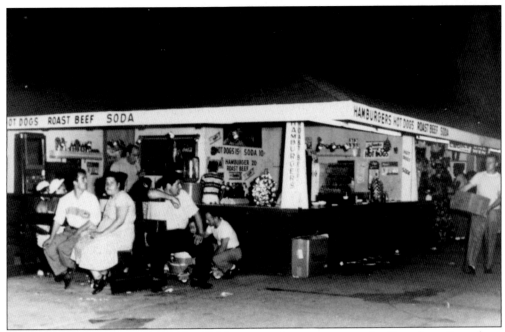

This refreshment stand, seen in the 1950s, was at the entrance to the Keansburg Steamboat Company pier. Most subjects seem tired after a long day, eager for it to end. If Keansburg signage had a similar appearance, the look may reflect the style of a single sign painter, Cortland Ogden, whose services were used by nearly all, as recalled by Paul Hunter. (Gehlhaus Archives.)

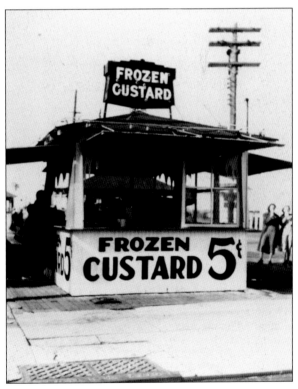

Lillian Gehlhaus Holobinko opened the first frozen custard stand in Keansburg in the 1920s on the boardwalk. This later stand, begun in the 1930s and seen here in the 1940s, still stands on Beachway at the foot of Carr Avenue. It was later operated by Henry F. Gehlhaus III, now co-owner of the amusement park. An anthropology graduate said of Keansburg, "I love this place. Nothing changes." Despite the timeless quality of much of old Keansburg, some things do change, such as the price of frozen custard. (Gehlhaus Archives.)

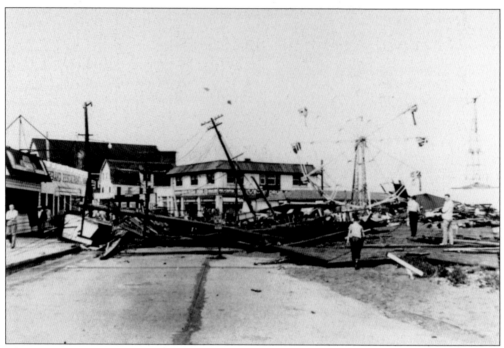

The September 1944 hurricane wrecked havoc throughout the borough, causing damage greater than any of the numerous storms that have visited over the decades. The boardwalk and steamboat dock were wrecked, the former replaced by the concrete pavement now called a boardwalk. This image looks west toward the drugstore building, viewed in the center (p. 89). (Gehlhaus Archives.)

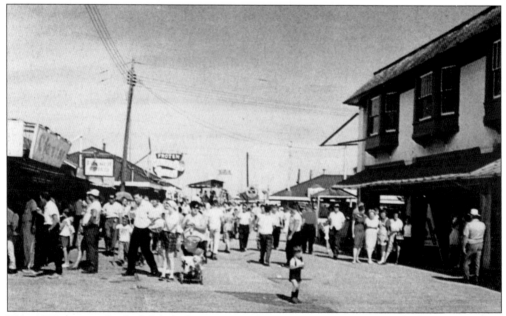

This 1950s postcard, which labels the scene "Midway," shows the range of the former boardwalk near Carr Avenue. The pavement is now called "boardwalk," with the locale the north side of the building in the center above.

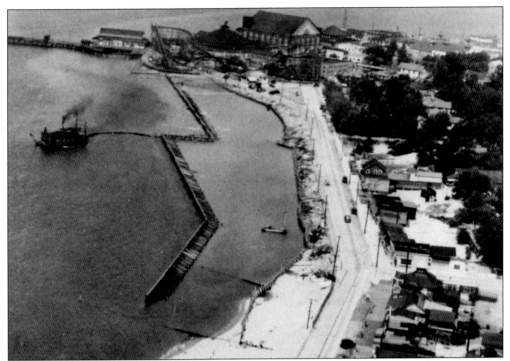

This 1940 aerial is looking northeast from the western stem of Beachway at the time of the construction of a jetty for shore protection. The Jack Rabbit (p. 25) is visible in its street context. The readily distinguishable conical and gable roofs of the dance hall and auditorium point to the amusement area's most active block. (Borough of Keansburg.)

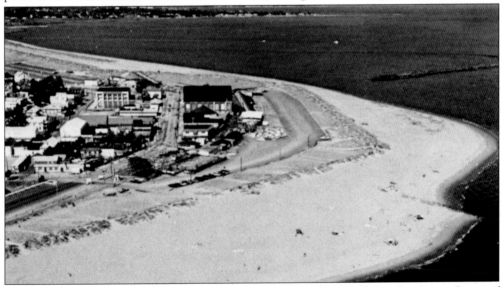

The $7.9 million Bayshore Hurricane Protection Plan, developed by the Army Corps of Engineers and the New Jersey Bureau of Navigation and begun in 1969, expanded greatly the width of some Keansburg beaches. This image is taken from a mid-1970s postcard view that looks west along Beachway. Carr Avenue is about in the center of the photograph, below the no-longer-existing Crystal Pool.

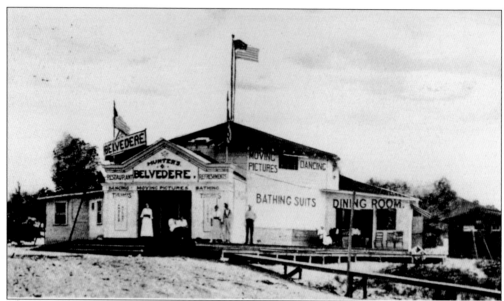

The Keansburg Heights Beach Company developed the shore west of the New Point Comfort pier, in time building a second pier. This 1912 casino, an early entertainment facility, was designed by key principal Paul C. Hunter and built by W.L. Hart; its signage reflected its varied activities. The core was a 40-by-40 foot octagon. A belvedere is a structure, often with an open roof or gallery, designed to command a view. This image is c. 1915. (Collection of John Rhody.)

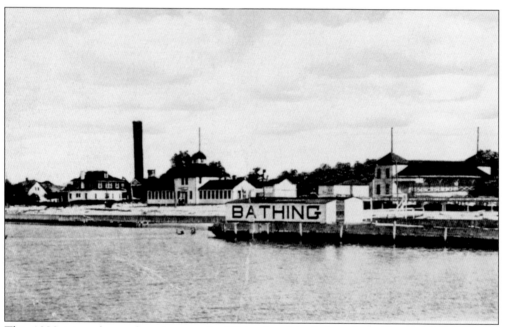

This 1920s view shows alterations to the "Belvedere," including the addition of wings and a cupola. The first and second of the town's water towers are at left. An amusement park was built around the early structure. The tower at the right in the rear was the entrance to the scenic railway or the Belvedere Beach roller coaster.

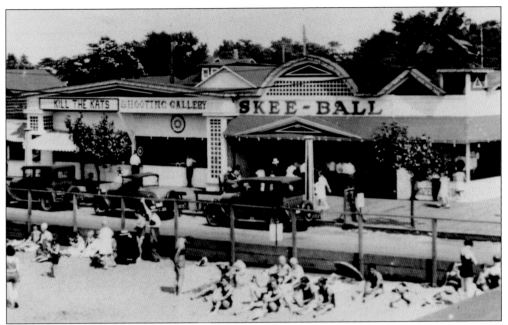

Keansburg Heights Beach was known as Belvedere Beach by the 1930s, distinguishing itself promotionally as "The Bright Spot" with a logo cartoon figure embracing a sun. This *c.* 1930 image shows a narrow stem of Beachway separating the amusements from the beach. Storms, erosion, and changing tastes have effaced the former character of Belvedere Beach. (Borough of Keansburg.)

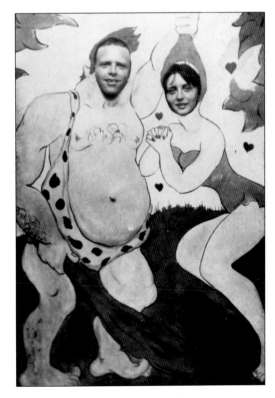

Paul C. Hunter is the grandson of the architect and developer of Keansburg Heights Beach shown on p. 106. He and wife, Paula, were long-experienced Keansburg amusement operators. What do game operators do when visiting other parks? Clown around, of course! Actually this 1960s trip to Coney Island resulted in their acquiring a device for their stand, as well as this cave denizen portrait. They are retired now, but remain enthusiastic spokespeople for Keansburg traditions.

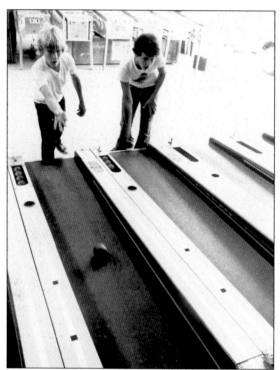

Skee-ball, the author's favorite amusement game, is usually cheap and always fun and one can make a kid happy by giving away the prize tickets. Skee-ball provides the tactile satisfaction of handling the ball, unlike electronic games. This boy is using the "straight-up-the-lane" method to roll. The author usually prefers to ricochet the ball off the side of the lane. User-friendly games provide a plastic "target" on the side. This image was taken in 1978, but the game's well-pitted balls are a lot older. The game at Doug's Arcade provided diversion during the author's field research. High score during the project? Only 320, but, hey, this is fun, not to be taken seriously.

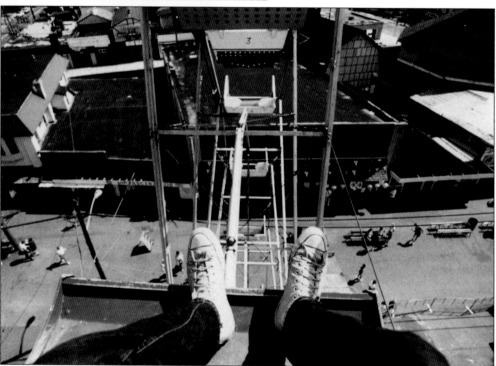

Some claim photography from the top of a Ferris wheel is a big feat, but the ride in Keansburg is not all that high. Still, staring at the color print of this 1980s image made the author's wife queasy, so you may not wish to gaze at this page for too long.

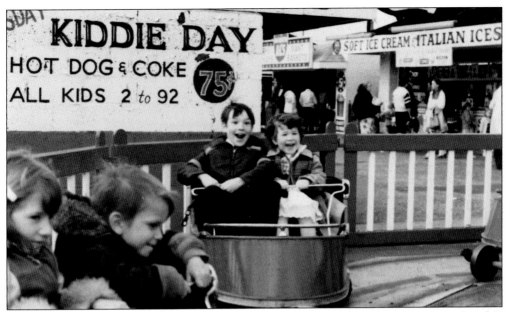

When ninety-two-year-old Henry Gehlhaus, son of the founder of the New Point Comfort Beach Company, saw this 1980 image, he indicated that the sign should be changed, noting there was no reason why kids of all ages should not be able to enjoy Kiddie Day. Tim and Kelly O'Rourke obviously had a good time on the whip.

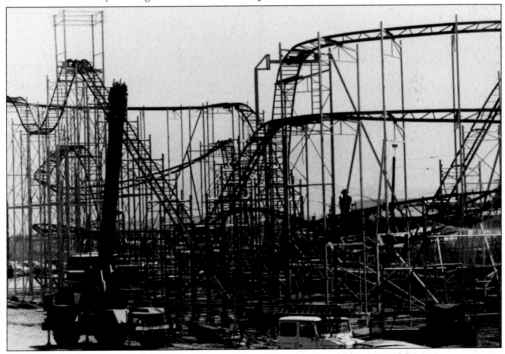

The roller coaster near the foot of Carr Avenue was promoted at its 1984 construction as the longest all-steel structure—the rides are traditionally wood—in the east. The ride seems modest today, as advancing technology and much larger structures elsewhere have eclipsed the Keansburg distinction. However, it still provides thrills to park visitors.

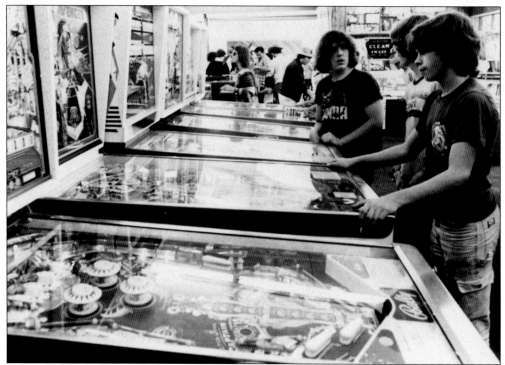

Pinball machines in 1978 were not yet overtaken by the multi-level, light- and sound-effect games that now prevail. There is a plain satisfaction in the older examples with their staccato bells of advancing scores and the familiar thump of balls hitting the bumpers. The balls would so often speed down the center of the board, not even close to the flippers, that one imagined their course was a groove, invisible to the naked eye, naturally.

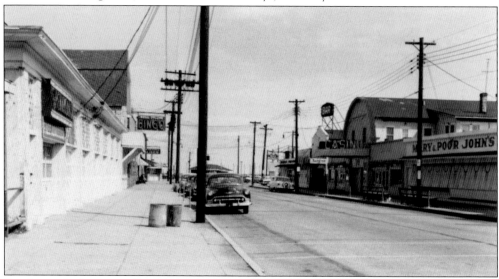

Beachway, looking east from Highland Avenue, has changed considerably since this c. 1952 picture. The north side (left) has been rebuilt following early 1980s fires. The theater at the right is gone. Note the bus sign in the distance, reflecting the growing importance of motor transport in the post-World War II era. (The Dorn's Collection.)

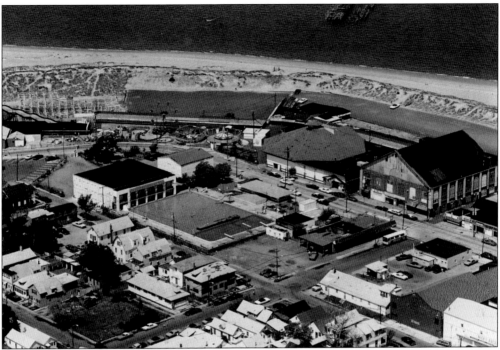

This *c.* 1980 view of the western end of the amusement district preceded the destruction by fire of most the north side of Beachway (including the dance hall and auditorium), the construction of the fishing pier at the pilings at top, and the removal of the large slide and Wild Mouse at left. Highland Avenue runs diagonally at bottom, and the block on the south side of Beachway is the site of the present Runaway Rapids water park (p. 48). The former Casino Theater and factory at lower right were also demolished. (The Dorn's Collection.)

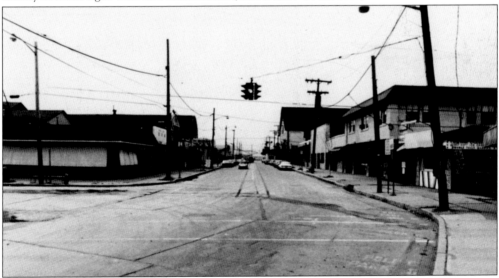

Beachway at Carr Avenue looking west in September appears ready for its winter respite, a state not unlike animal hibernation. Resorts have their predictable patterns. The months will pass, with some changes and repairs made in a long spell of little activity. The crowds will emerge around the next Palm Sunday and the cycle, not unlike nature's, will begin anew.

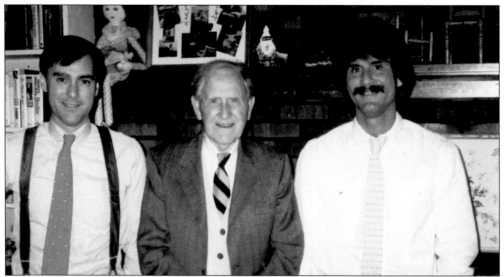

Henry F. Gehlhaus (son of the founder, William—see p. 20) poses in 1996 flanked by sons William H. (left) and Henry F., known as Bill and Hank. The elder Gehlhaus sold the Keansburg Amusement Park in 1972, while his sons bought it back in 1995. Bill is a lawyer and member of the Atlantic Highlands Borough Council; Hank manages day-to-day park activities. The return to original family ownership caused the elder Gehlhaus to reflect on the park's long-held appeal to families, "We always attracted families by giving good value. We did so early in the century and we do so today."

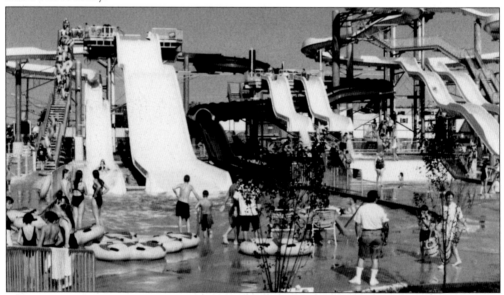

The return of the park to Gehlhaus family ownership was followed immediately with a spruce-up campaign and the start of construction in late 1995 of a water park built on the Beachway block that once included the former Crystal Pool (p. 27). Runaway Rapids, designed by water slide specialist Fred Langford of Cape May Courthouse, New Jersey, opened in June 1996. The park, which reflects the Gehlhaus' orientation toward family fun in the easy-to-use slides, was an immediate hit. The costly investment is a popular indicator of the owners' optimism and a renascent Keansburg amusement district.

48

# Three

# Hospitality

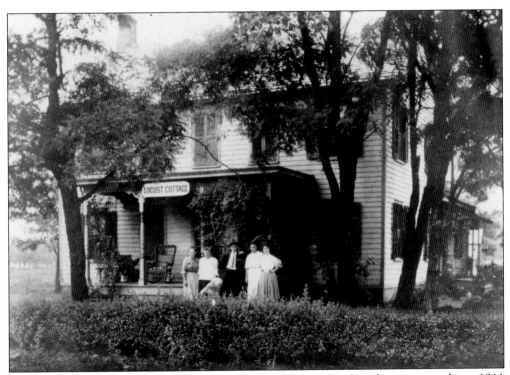

Kate Wilson's Locust Cottage, located opposite the Raritan Bay Hotel, was reported in a 1911 account of a lawn party as one of the most popular boarding houses in Keansburg. It is the Wilson family homestead and, although one of Keansburg's older buildings at the time of this *c.* 1910 image, its history has not been revealed. (Borough of Keansburg.)

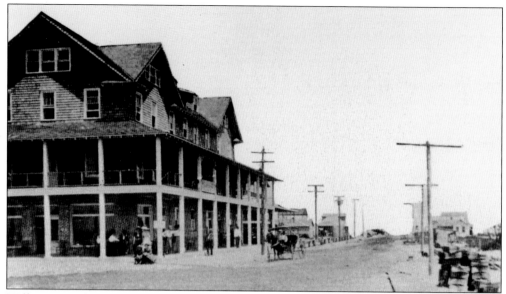

William A. Gehlhaus built the New Point Comfort Hotel *c.* 1910 at the foot of the Keansburg Steamboat Company pier and Beachway. This *c.* 1910 view looks east on Beachway prior to the substantial construction that would soon follow. Note the construction materials at right. The hotel accommodated Gehlhaus' maritime passengers, facilitating Keansburg as a vacation destination. (Collection of John Rhody.)

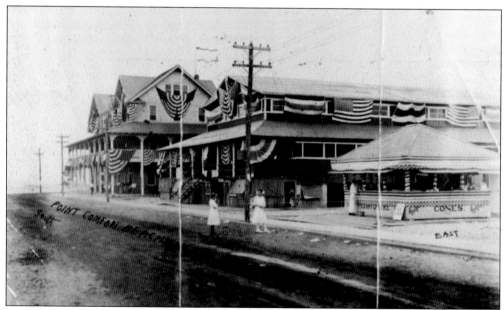

A dance hall was built in 1910 by W.L. Hart adjacent to and east of the hotel. Its building contract did not specify an architect, but indicated the project was under the direction of William A. Gehlhaus. It is seen *c.* 1910 with the buildings decorated for an unspecified occasion. This hall, also known as the excursion pavilion, was apparently moved to a spot near the pier *c.* 1915 when the auditorium was built. The hotel was destroyed by fire on September 23, 1917, and was not rebuilt, despite the announcement of plans to do so. (Gehlhaus Archives.)

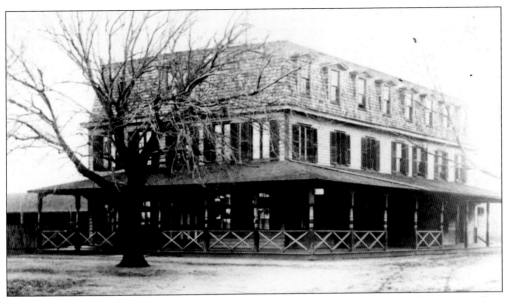

The Raritan Bay Hotel, 215 Main Street at its northwest corner with Frances Place, was built in stages, with its origins a private dwelling. It is seen here *c.* 1910. William L. Macdonald bought it in the early years of this century, turning it into a showplace. He added a pavilion behind the hotel in 1912. The Raritan's Grill Room, a popular spot for elegant dinners and private gatherings, often featured singing waiters and dancing. The Catholic church held mass here beginning *c.* 1912, prior to the erection of St. Ann's. Macdonald died in 1927, with ownership passing several years later to his nephew George. (Collection of John Rhody.)

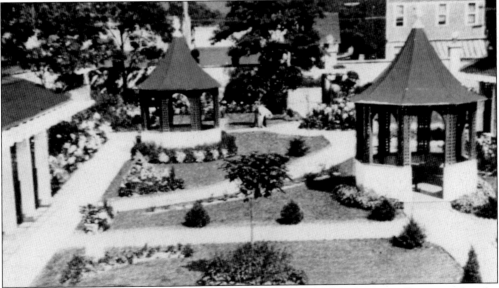

Macdonald designed elegant formal gardens adjacent to the hotel, reportedly using ideas he obtained in Cuba. The name Flamingo Bar was added *c.* 1953, following the acquisition of another establishment's liquor license several years after George Macdonald lost his. The place, later known as Apple Annie's, deteriorated, owed substantial back taxes, and was boarded-up when it was demolished in May 1991. Friendship Park is now on the site of the hotel and the Main Street Manor condominiums are on the garden lot. (Collection of John Rhody.)

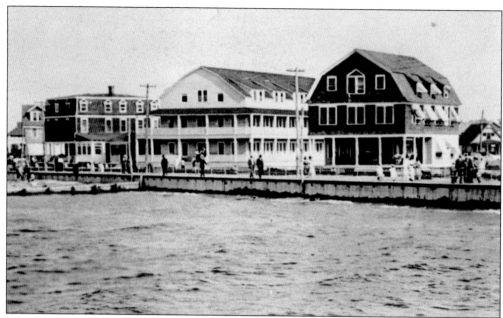

The Sea View, Holland House, and East View House, from the left, were three of the principal New Point Comfort hotels built *c.* 1910 on the Beachway block between Raritan and Fairview Avenues. The hotels are gone, demolished for a 1960s urban renewal project, and the beach is expanded. A ball field is now on the block. (Gehlhaus Archives.)

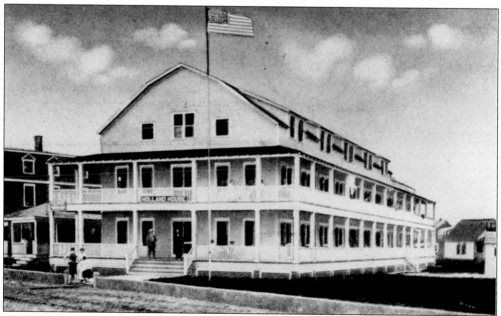

The Holland House was built *c.* 1910 on Beachway between Raritan and Fairview Avenues. It is the familiar Keansburg two-and-a-half-story, front-gabled, gambrel-roofed hotel, but this example is distinguished by its extensive wrap-around porches. This postcard view is *c.* 1915. (Collection of John Rhody.)

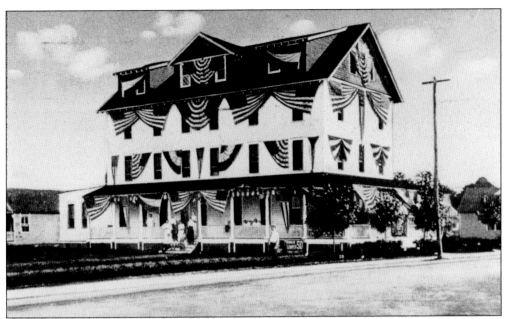

The White House, built in 1912 by contractor Frank Johnson for Edward and Richard Steppanski of Jersey City at 4 Sea View Avenue, was reported to be one of the largest boarding houses in Keansburg with fifty rooms planned. (One wonders if the listing on p. 66 or the announcement is in error, or if the rooms were reconfigured.) Its former elegance long gone, it was a troubled rooming house in its later years and was demolished in May 1996, with its owner in considerable tax arrears. The lot remains vacant. This image is a *c.* 1915 postcard. (Collection of John Rhody.)

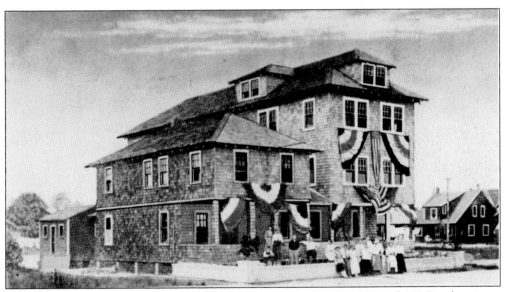

The 22-by-75 foot Koehler's Villa was built in 1914. The hotel at 127 and 129 Beachway was converted to a rooming house, but is instantly recognizable today, although siding has replaced the shingle cladding. The dormers remain, but entrances are changed and a one-story extension was built on the side, or right. This image is a *c.* 1915 postcard. (Collection of John Rhody.)

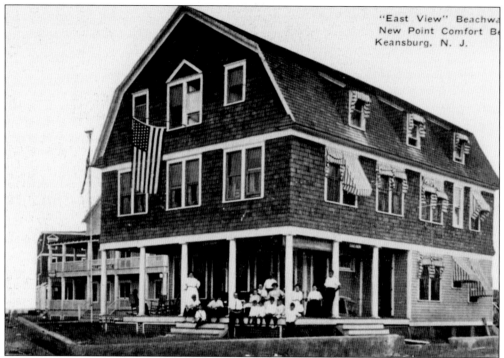

"East View" Beachwa
New Point Comfort B
Keansburg, N. J.

Max J. Korber hired contractor Frank Johnson in 1912 to build the East View House at the southwest corner of Beachway and Raritan Avenue. The two-and-a-half-story, hipped-roof, front-gabled Colonial Revival-style boarding house was announced as having running water in every room, apparently an advance for the times. This view is taken from a *c.* 1912 postcard. (Collection of Michael Steinhorn.)

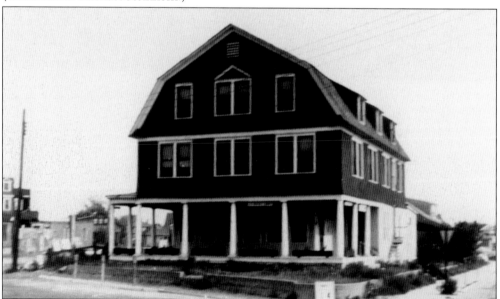

The East View House was remarkably unchanged after half a century. Long past its prime, it was merely called Parcel 14 when photographed in the 1960s for the urban renewal land acquisition project. A ball field is on the site now. (Borough of Keansburg.)

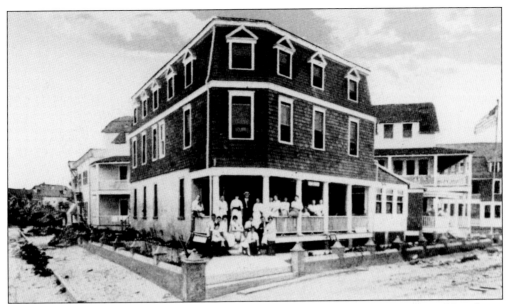

The Sea View Cottage was likely built in 1911 and was located on the corner of Beachway and a no-longer-existing Far View Avenue. Mr. E. Amon was the early proprietor. The construction takes advantage of its corner locale, while the Mansard roof distinguishes it from the typical Keansburg boarding house. See p. 52 for the Sea View's street context. (Collection of John Rhody.)

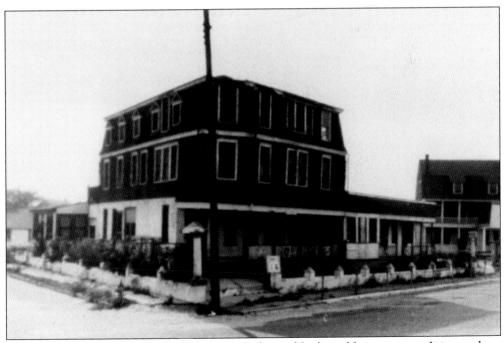

The Sea View Cottage, although deteriorated, changed little in fifty years or so. It is seen here awaiting acquisition for urban renewal clearance. (Borough of Keansburg.)

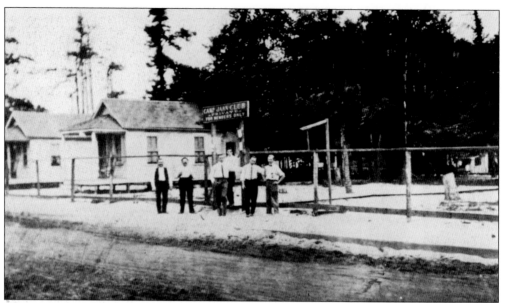

Several turnverein—from the German *turnen*, "to practice gymnastics," and *verein*, "club or union"— were founded in Berlin in 1811 by Frederick Ludwig Jahn. The organizations, centers for the promotion of health and physical culture, were established in the United States in Cincinnati in 1848. Essex and Hudson County interests secured land *c*. 1906 and established a camp named for the German founder. They built a large pavilion in 1908 and pitched tents as necessary for their members. (Borough of Keansburg.)

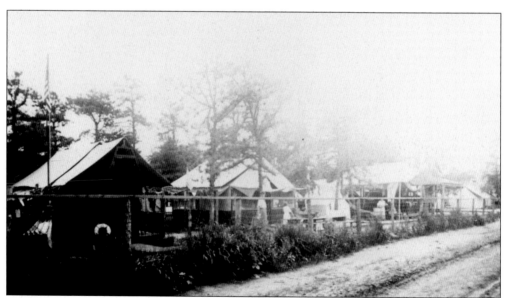

Camp Jahn had streets running through a colony of permanent buildings and tents, which could be reached through an entrance with an attractive arch. The camp's early physical instructor was August E. Rueger. Many undocumented pictures of the tent city exist, which one hopes will be supplemented by first-person accounts to present a better idea of life there. (Collection of John Rhody.)

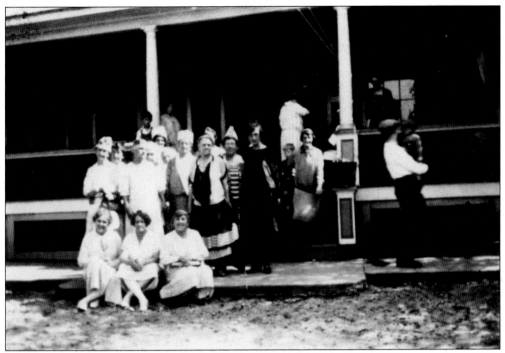

These women at Camp Jahn were photographed on August 10, 1927, without notation of the day's activity.

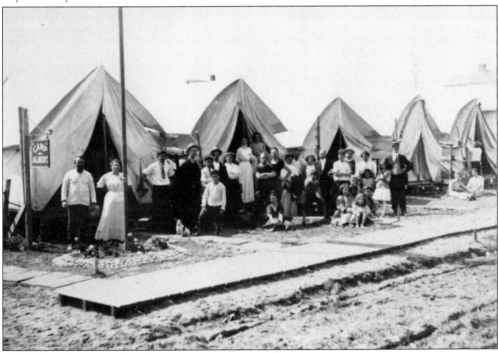

Numerous names on tent colonies appear in Keansburg photographs; they are typically undocumented. Camp Albert is said to have been a World War I re-naming of Camp Jahn, but contemporary research is needed to confirm this. (Gehlhaus Archives.)

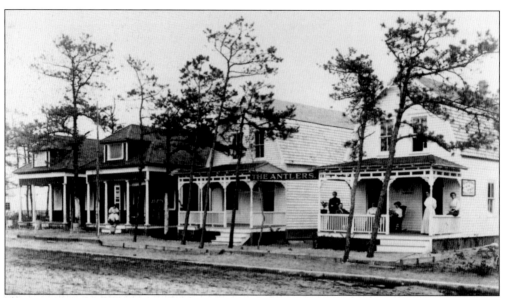

The four cottages at 34–40 Ocean View Avenue still stand, their porches enclosed, with their cladding and windows generally changed. "The Antlers" sign denotes a boarding house run by Mrs. W.D. Ellingsworth, seen here in a c. 1910 image. (Gehlhaus Archives.)

The Leonora Villa appears to have been a small, attractive Colonial Revival boarding house known to have been on Ocean View Avenue. Note the unusual gambrel dormers, matching a virtual "Keansburg hotel style" roofline. The place, seen in a c. 1913 postcard, seems to have disappeared from the one-block street. Old maps suggest it may have been on the northwest corner with Center Avenue. (Collection of Michael Steinhorn.)

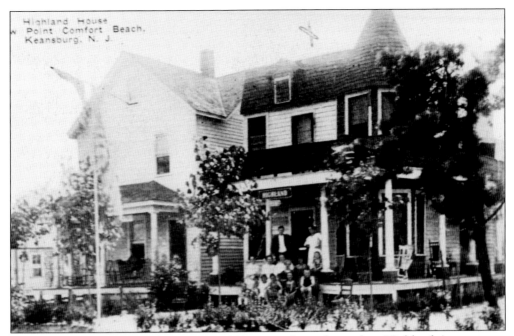

The Highland House, seen here in a c. 1912 postcard, was located on Highland Avenue near Center. It is believed to have been destroyed by fire after a long period of vacancy. (Collection of John Rhody.)

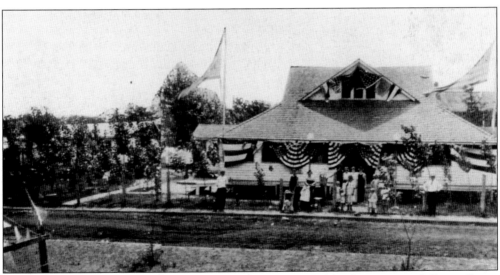

The Imperial Hotel was built by 1911 on the corner of Highland Avenue and Green Grove Place (now known as Highland Boulevard) when it was operated by Mrs. Robert J. Armstrong. Seen here in a c. 1912 postcard, the Imperial left the landscape at an unspecified time, cause unknown. (Collection of John Rhody.)

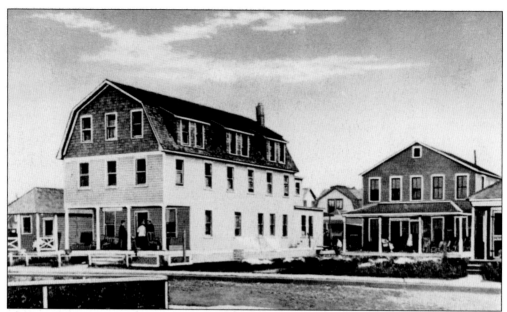

The Bay Side House and Veronica cottage were located on Grandview Avenue, near Beachway. The street has been obliterated, the area now covered by the Grand View Apartments. This is a c. 1918 postcard view. (Collection of John Rhody.)

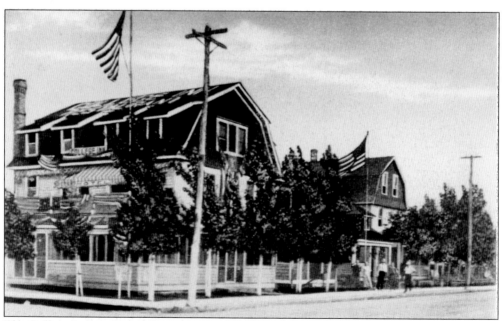

The College Inn on the southeast corner of Highland Avenue and Seabreeze Way, seen in a c. 1915 postcard view, was long a summer boarding house. The place, remodeled to accommodate apartments, sustained fire damage on May 24, 1996, resulting in its present boarded-up condition. The building is recognizable, major changes in its cladding and windows notwithstanding. (Collection of John Rhody.)

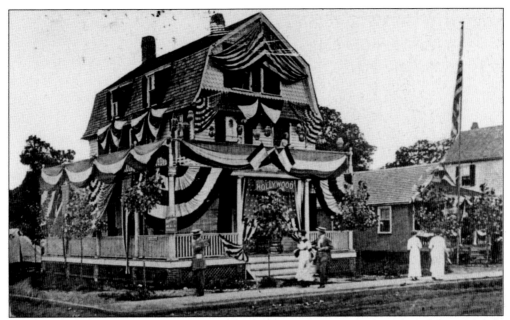

The Hollywood Cottage, an appealing, shingle-clad, gambrel-roofed, Colonial Revival-style hotel, looked especially impressive decorated with bunting *c.* 1915. It was operated by Mrs. Henry Weseman by 1911 and located at the southeast corner of Carr and Center Avenues. The Hollywood was last seen with a Laundromat on the first floor, the building in a shabby state awaiting destruction in the 1960s urban renewal project. Garden apartments fill its block now. (Collection of John Rhody.)

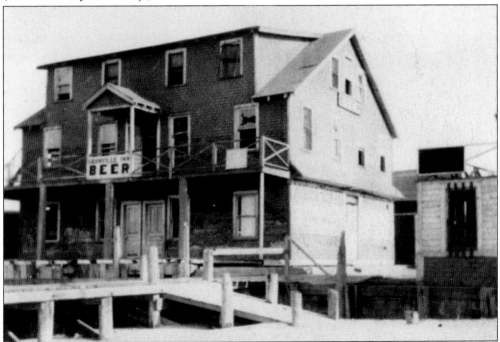

The Granville Inn stood near the beach. Its exact location appears to have slipped from current memory, but one would expect a Granville Park locale. (Borough of Keansburg.)

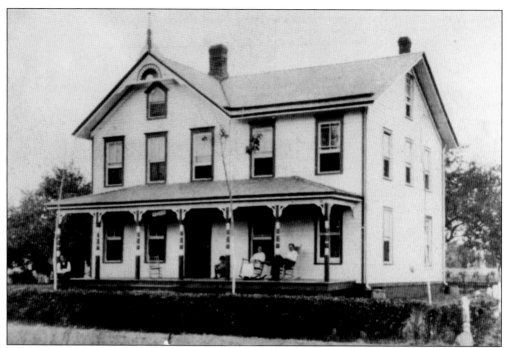

The Shady Side was a Main Street boarding house operated by Mary Broander beginning in the late nineteenth century. Set back from the street, the building is now accessed through Broander Place as later construction was placed between it and the street. The now private residence, probably built in phases over the nineteenth century, is readily recognizable, its appearance not obscured by shingled siding, an enclosed porch, and the absence of its chimneys.

Eadies Den, located in Keansburg Heights, was reported destroyed by fire *c.* 1980.

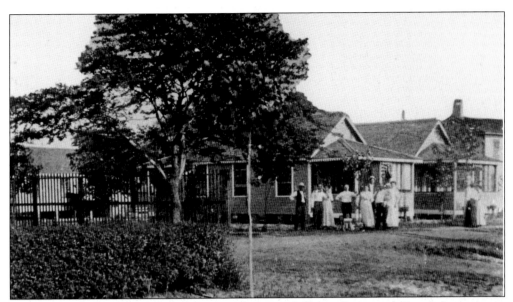

Seeley Schuck built these cabins c. 1910 at the corner of Main Street and Center Avenue near her home, the former Robinson house. The places still stand, remodeled as year-round houses. (Collection of John Rhody.)

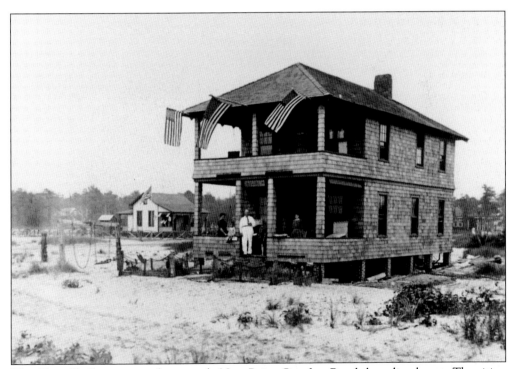

The Clam Shell appears to be an early New Point Comfort Beach boarding house. The siting shows a wooded area near the beach and filled marshes that characterized the amusement district at its 1906 beginning. (Gehlhaus Archives.)

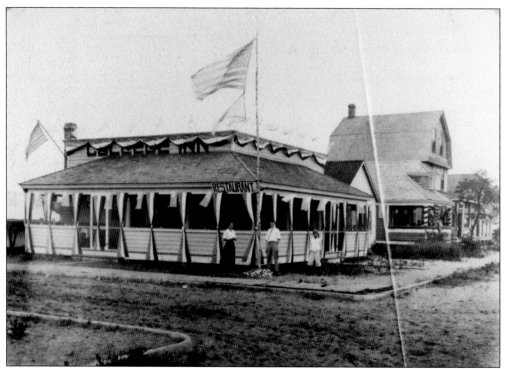

This unidentified restaurant is an example of a Gehlhaus improvement to accommodate visitors in the early development period. (Gehlhaus Archives.)

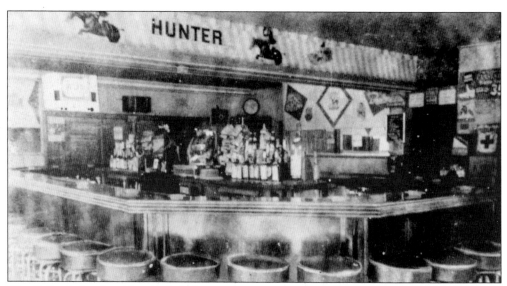

The Balbach brothers' bar included a catering operation, with an auditorium that booked a variety of events. Bill and Gus were boxers, with the latter having held a state championship. The auditorium opened in June 1937 with a wrestling exhibition. The brothers also presented Broadway-style floor shows and Saturday night dancing. Located on the southwest corner of Carr Avenue and Oak Street, this place was destroyed by fire c. late 1980s. Housing is on the site now. (Gehlhaus Archives.)

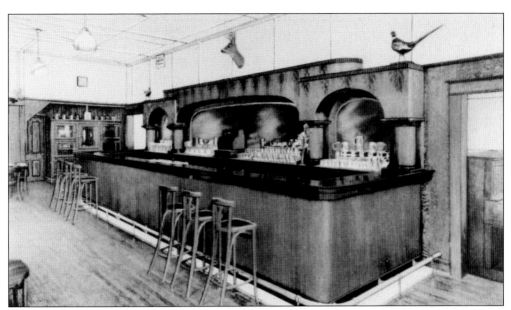

George E. Kauffmann Sr. bought the Centre Hotel at 67 Carr Avenue in 1921. He remodeled its grade-floor delicatessen in 1933 (repeal!) to a bar, installing this fine mahogany counter built by Brunswick Balk. His son, George Jr., converted this front room to a retail package store in the 1970s, then retaining a bar in the rear. The store is still quite active, but the bar was closed and is now a workshop for George's wood carvings. George observed that contemporary bars are primarily Formica, a fact which has perhaps caused the barman's expression, "decorate the mahogany" (show your money) to fade from use. (Collection of John Rhody.)

The Belvedere Cocktail Lounge in the former Hotel Belvedere at Laurel and Maplewood Avenues was an attractive, well-stocked bar. The number of liquor licenses in Keansburg, about thirty-four at one time, was predicated on its summer population of transients, giving the town more bars than one would expect for a municipality its size. (Collection of John Rhody.)

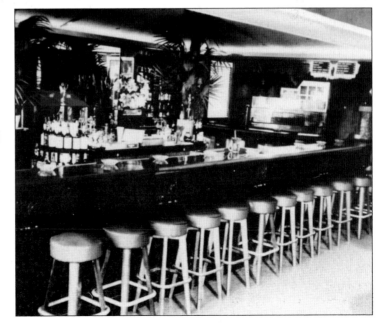

# HOTELS AND BOARDING HOUSES

| | ROOMS | RATES |
|---|---|---|
| ATLANTIC HOTEL, Beachway | 45 | $10 and up |
| BERKSHIRE HOTEL, Center and Pineview Aves. | 20 | $18-$20 |
| HOTEL CENTER, Center and Carr Aves. | 20 | $10 and up |
| HOTEL HOLLYWOOD, Center and Carr Aves. | 20 | $10 and up |
| IMPERIAL HOTEL, 14 Highland Boulevard | 17 | $10-$12 |
| JOE'S HOTEL, 60 Carr Avenue | 12 | $10-$14 |
| LAUREL HOTEL, Laurel Ave. and Charles Ave. | 35 | $10 and up |
| MAHLER HOTEL, Laurel Ave. and Highland Blvd. | 35 | $15-$18 |
| MAJESTIC HOTEL, Carr Ave. and West Shore St. | 22 | $10-$18 |
| MELROSE HOTEL, Highland Blvd. and Highland Ave. | 15 | $12 and up |
| MASSACHUSETTS HOTEL, 8 Oceanview Avenue | 14 | $12 and up |
| PORTER'S HOTEL, 125 Carr Avenue | 30 | $10-$12 |
| RARITAN BAY HOTEL, 211 Main Street | 25 | $10 and up |
| ST. CHARLES HOTEL, 2 Maplewood Avenue | 12 | $10-$14 |
| BEACON HOUSE, 49 Maple Avenue | 20 | $10 and up |
| CAMP RARITAN, Beachway at Pier | 12 | $10-$12 |
| COMMODORE HOUSE, 137 Main Street | 10 | *$15 |
| EAST VIEW HOUSE, Beachway | 18 | $12-$14 |
| MORCHAUSER VILLA, Center & Camp View Aves. | 10 | $12-$14 |
| MAPLEWOOD HOUSE, 88 Maplewood Avenue | 10 | $10 and up |
| MANSION HOUSE, 123 Sea Breeze Way | 14 | *$20 |
| RARITAN VIEW HOUSE, 15 Raritan Avenue | 12 | $10 and up |
| SEA VIEW HOUSE, Beachway | 20 | $12-$14 |
| SCHLAGG'S VILLA, 47 Raritan Avenue | 15 | $10 and up |
| WHITE HOUSE, 4 Sea View Avenue | 22 | $10-$14 |

* Meals Incl.

## ROOMING HOUSES AND APARTMENTS

| | | |
|---|---|---|
| BAYSIDE HOUSE, 32 Grandview Avenue | 15 | $12-$14 |
| BEACH VILLA, 12 Grandview Avenue | 18 | $12-$14 |
| DILLON HOUSE, 49 Shore Boulevard | 26 | $20-$25 |
| HOLLAND HOUSE, Beachway _____ Housekeeping Privileges | | $10 and up |
| WASHINGTON HOUSE, 42 Carr Avenue | 18 | $10 and up |
| OAK DALE HOUSE, 49 Ramsey Avenue | 14 | $12-$14 |
| | Housekeeping | |
| DELAWARE HOUSE, 44-46 Carr Avenue | Privileges | $10-$12 |
| WILBEN HOUSE, 29-31 Oceanview Avenue | 30 | $10 and up |
| VINCENT HOUSE, Main and Maple Avenue | 25 | $10 and up |

## BUNGALOWS AND COTTAGES

| | | |
|---|---|---|
| Choice 3-4 Room Bungalows | $200-$400 | per Season |
| With all Improvements | $100-$150 | per Month |
| | $20-$35 | per Week |

## APPLY TO THE FOLLOWING LICENSED REAL ESTATE BROKERS FOR RESERVATIONS

| | Phone Keansburg |
|---|---|
| CONROY, WALTER A., Church Street at R. R. | 217 |
| COMPTON, B. S., Main and Collins Street | 254 |
| COOKE, MRS. EDW. S., Myrtle Avenue | 623 |
| GELHAUS, OTTO F., 82 Beachway | 56 |
| LICARI, PETER Belvedere Peach | 88 |
| MORRISEY AND WALKER, Inc., Main and Church Streets | 1 |
| NEW POINT COMFORT BEACH CO., Beachway and Carr Avenue | 66 |
| OGDEN AND SONS, 64 Carr Avenue | 426 |
| OPDYKE, HOWARD C., 14 Charles Street | 64-W |
| PAPA, JAMES V., 342 Palmer Avenue | |
| PRICE, MRS. A., 184 Park Avenue | 107 |
| PALMER, A. J., Francis Place | 35-M |
| RUTLAND REALTY CO., (A. A. Nightingale) 38 Carr Avenue | 229 |
| SHRODES, CHARLES, 9 Morningside Avenue | 233 |
| WALTER, SAMUEL, 303 Main Street | 404 |
| VEIX, HARRY 55 Highland Avenue | 373 |
| WILLIS, WILLIAM B., Main and Church Streets | 372 |

This cross-section of hotel and real estate organizations was listed in a c. 1930 promotional brochure. Research of Keansburg's hospitality business is handicapped by establishments' changing names, vague early references to location (which often mentioned only the avenue name), and the disappearance of businesses without the means or dates being recorded in an accessible form. Some old hotel/boarding house (even that designation seems to have been used interchangeably) structures remain with their occupancy changed; many are private residences.

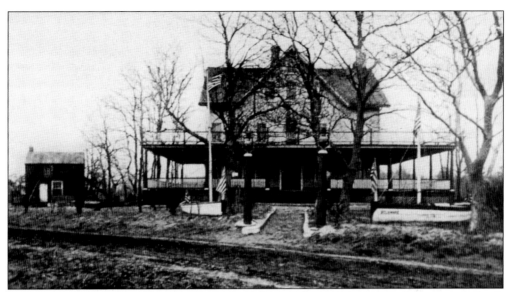

The Meadow Brook Hotel, seen on a c. 1912 postcard, occupied a triangular corner at Creek Road and Seeley Avenue. The 12-foot porch was built in 1911, the same year the place was wired for electricity. It had been in a state of ruin prior to its disappearance by unspecified causes, likely in the early 1950s. (Collection of John Rhody.)

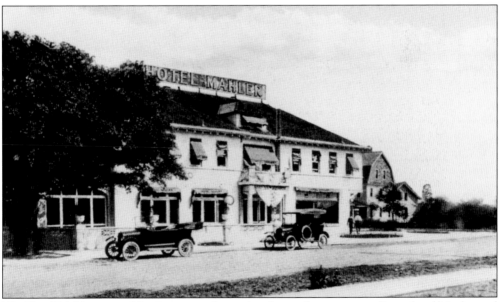

The Hotel Mahler, named for the owners, located at the northeast corner of Laurel and Maplewood Avenues, was a showplace troubled by its locale west of the amusement district. It was extensively damaged in a 1916 fire, which may have taken away its upper stories. Seen here on a 1920s postcard, it also sustained heavy damage in a 1935 fire. (Collection of John Rhody.)

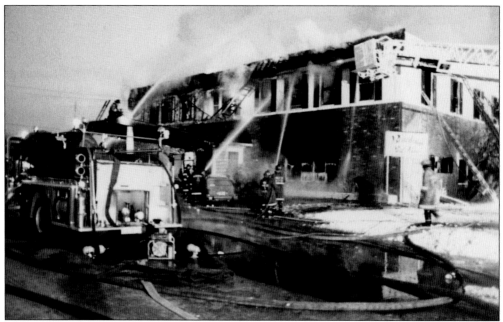

The former Hotel Mahler was converted to a boarding house in 1969, while a one-story, concrete, intermediate care facility was added in 1972. The place was gutted by a fire on January 9, 1981, that killed thirty residents. The toll could have been higher were it not for the home's regularly conducted fire drills. The conflagration caused the highest number of casualties ever in a New Jersey building fire, although greater numbers of lives have been lost in maritime and aviation disasters.

The Beachview fire, along with the 1980 Brinly Inn fire in Bradley Beach and contemporary hotel fires elsewhere, prompted review of safety regulations resulting in the Fire Safety Act of 1983. It contained extensive regulatory changes for public buildings, notably the widespread use of automatic sprinkler systems. The Beachview Rest Home at 32 Laurel Avenue is seen in January 1982, shortly after reconstruction. This nursing home appears the same, with maturing trees marring the view of the building.

*Four*

# Community Life

This charming 1975 St. Ann's cheerleading squad appears ready to shout mightily for its teams.

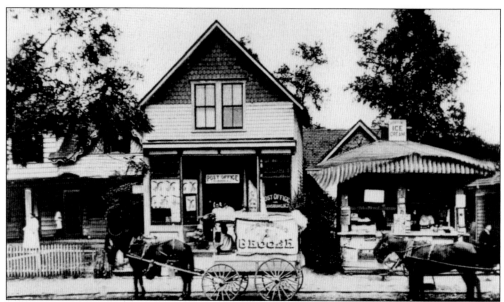

The region that became Keansburg earlier had a short-lived post office. The Granville Post Office was opened in April 1854 and closed the following March. The Keansburg office was opened in 1884, the name having been chosen to avoid confusion with Granville, NY (p. 105). The early office was located in the W.W. Ramsay store, but the facility was moved to the Ackerman building on the north side of Church Street opposite the railroad station in 1907. This image is a taken from a c. 1908 postcard. (Collection of John Rhody.)

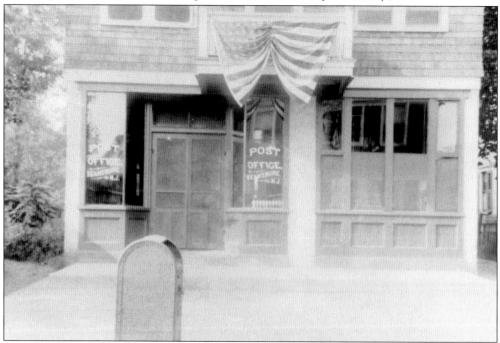

The Keansburg Post Office was enlarged in 1912 to accommodate its growing business. Although the building was considerably expanded, it is easy to compare the former and later facades by viewing these two pictures.

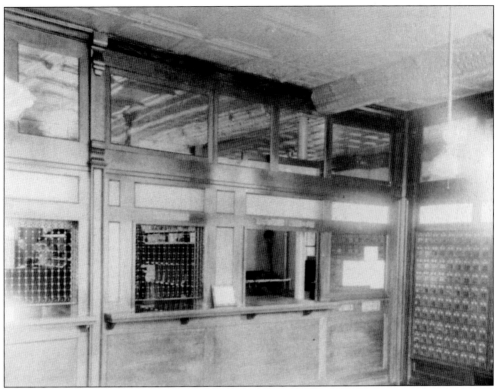

An October 9, 1912 *Register* account reported, "Three windows will be put in the side and 25 lock boxes and 475 call boxes will be put in and the old boxes taken out."

Benjamin Covert was the builder for the 1912 work. The two preceding images and this view showing the sorting area were likely photographed when that project was completed.

Arabelle Campbell Broander, known as Belle, was born 1887 in Keansburg, the child of John and Mary. She was educated locally, excepting one year at the Brockton Academy, and began work at the Keansburg Post Office at an early age. Belle became the town's second postmaster in 1913; during her tenure Keansburg rose from a fourth- to a second-class office. She was active with the Keansburg Methodist Church and in numerous civic affairs, including the World War I Red Cross and Liberty Loan drives. She died in 1924 from injuries sustained in a bus-trolley accident while in Indianapolis for a national convention of postmasters.

Belle Broander was widely loved and admired. Keansburg residents presented her with a gold watch with a diamond-studded case for her services in obtaining street letterboxes and delivery services. A town stunned by her accidental death soon formed a memorial association, expecting to erect a tablet in her honor. The successful fund-raising campaign permitted the construction of a monumental seat, placed in front of the Frances Place School. It was dedicated on Memorial Day, May 30, 1927. The settee, viewed in a recent image, may be seen today on the school grounds.

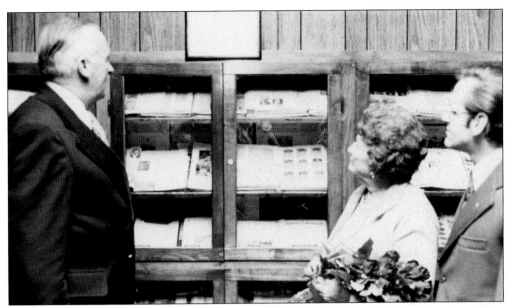

Longtime Borough Clerk Richard A. Jessen collected Keansburg photographs, documents, articles, and memorabilia for many years. His collection, supplemented by that of then-borough historian Jerry Freda, was presented to the borough on January 7, 1976, and placed in storage cabinets in the rear of the borough's meeting and courtroom. Pictured at the dedication are Mayor Eugene Connelly, Mrs. Jessen, and Mr. Freda. The pictures in this book labeled "Borough of Keansburg" were copied from this collection.

The borough family paused for this photograph at Connor's Highlands c. 1960. Members are, from left to right, as follows: (front row) J.F.S. Martin, William Turner Jr., Henry Schweitzer, and John Beatty; (back row) Clinton B. Lohsen, Alphonsus McGrath, Richard A. Jessen, Joseph Cohn of the Hudson Bus Company, and Charles McGuire. (Borough of Keansburg.)

The Keansburg School, seen in a *c.* 1905 postcard, was built on Church Street around the future site of Myrtle Avenue *c.* 1871 and expanded *c.* 1880s. It was the second school for the then Granville District and was replaced by the 1912 building. This structure was sold at auction in 1913 to Charles Carr, and then moved and remodeled into a house. (Collection of John Rhody.)

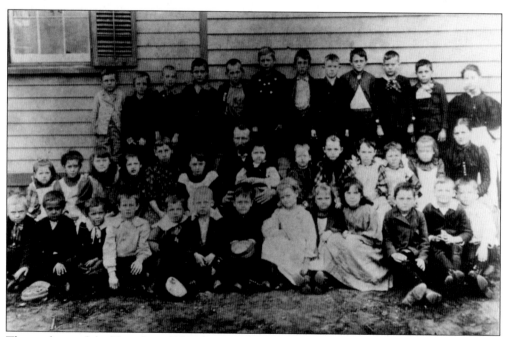

The students of the Keansburg School are seen in a *c.* 1895 image. John Broander is seated in front, second from the left.

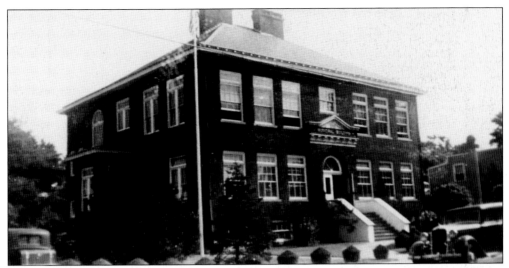

The two-story, hipped-roof, Colonial Revival Church Street School, designed by Henry A. Young of Keyport, was begun in 1912 and completed for the September 1913 school year. Expanding enrollment resulted in the construction of the Frances Place School in 1921, with both schools educating Keansburg's youth for several years. The Church Street School was later remodeled for a borough hall. It was occupied as such until the May 1997 move of borough offices to the former bank building (p. 96). It was demolished in June 1997, with Senior Citizen Housing planned for the site. (Collection of John Rhody.)

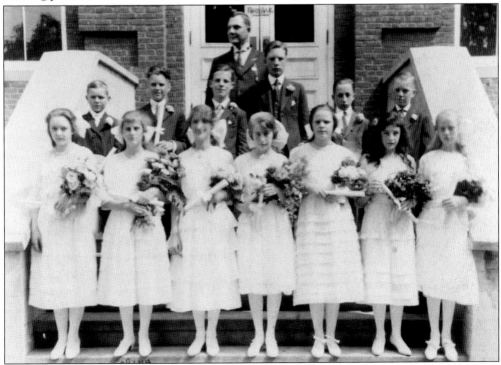

This is Corina Graves' eighth-grade class, but regrettably the year is unknown. Corina is second from the left. The graduates seem well attired for an elementary school celebration. (Borough of Keansburg.)

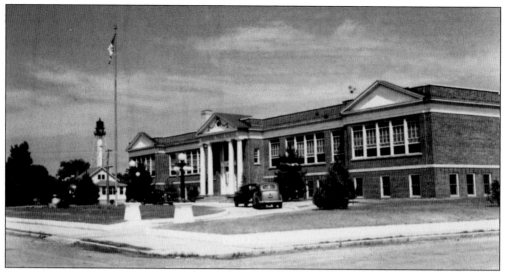

The Keansburg Public School, later the Frances Place School, was built in 1922 on the north side of Frances Place between Myrtle and Ransay Avenues and designed by John Noble Pierson & Son of Perth Amboy. This c. 1950 image shows its four-room beginning, to which a major addition was made by the same firm in 1926 that is visible in the aerial on the top of p. 100. The contractor's successor, Pierson and Macwilliam, designed the one-story addition built on the north in 1949. The school was renamed recently for Joseph C. Caruso, whose thirty-seven-year educational career included tenure as Keansburg's superintendent of schools from 1979 to 1995. (The Dorn's Collection.)

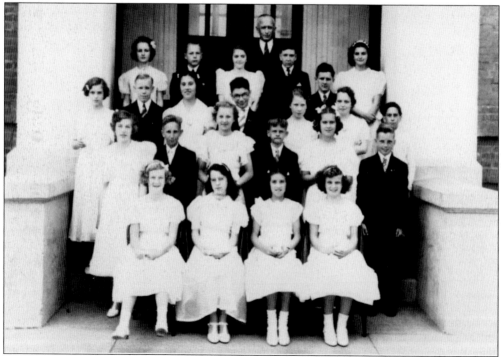

This class has a 1940s look, but also glum expressions on nearly all students other than those in the first row. Why? (Gehlhaus Archives.)

The successful Belle Broander memorial campaign prompted residents to commemorate the service of its veterans. A 14-foot, 5-inch, polished granite Ionic shaft on which rests a dark, polished ball was erected in front of the recently demolished borough hall. The monument, seen here in a c. late 1920s image, was dedicated on July 4, 1927, with Congressman Harold Hoffman as the principal speaker. Ivy obtained from the battlefield at Verdun was planted at its base, but it is no longer extant. The monument is inscribed: "Erected in memory of those who made the Supreme Sacrifice in the World War from Keansburg and vicinity." (Gehlhaus Archives.)

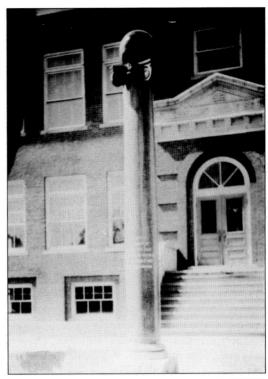

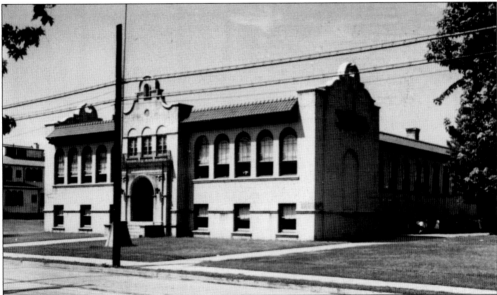

St. Ann's School on Carr Avenue was designed by Red Bank architect Vincent J. Eck, who had numerous commissions from the Catholic church, in the Spanish Mission Revival style of the church. It was dedicated in July 1931, opening that September. The look of this c. 1955 image has been altered, not only by the erection of a 1961 six-bay addition on the south, but by the removal of its architectural details. Gone are the round, arched windows, the door enframement, balustrade, and Mission-shaped roof parapets, with only the roof tile now providing a hint of the building's former architectural distinction. (The Dorn's Collection.)

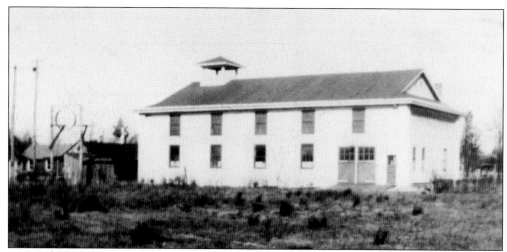

The Independent Fire Company firehouse was on the northeast corner of Main Street and Port Monmouth Road from *c.* 1919 to 1922. The company was absorbed by Keansburg Fire Company No. 1 in 1922. This building's later occupants included the Cameo Theater; it is now a bar. Note the early alarm signal, a locomotive wheel rim that was struck with a sledgehammer. (Borough of Keansburg.)

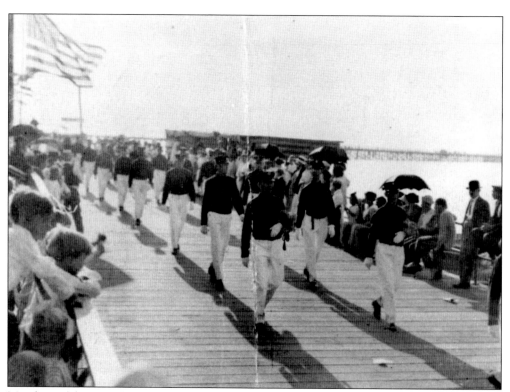

Members of the Keansburg Fire Company No. 1 march on the boardwalk, probably at an August carnival, *c.* 1915. (Borough of Keansburg.)

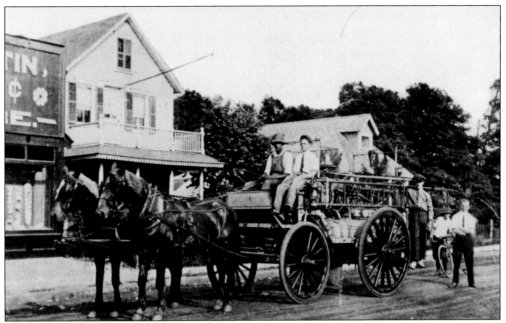

The New Point Comfort Fire Company was formed in 1913. Their early operation was as a bucket brigade, but this horse-driven chemical engine was acquired by c. 1915. The two Keansburg fire companies were organized as a municipal department in 1923. (Borough of Keansburg.)

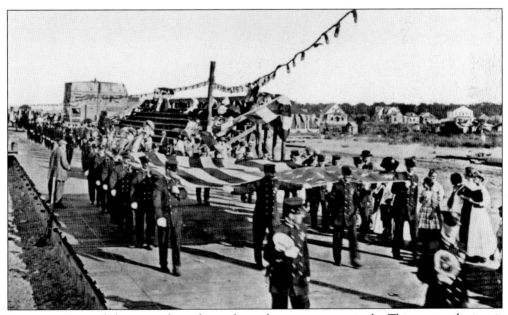

Firemen competed for a number of awards at the summer carnivals. This postcard view is c. 1914. (Borough of Keansburg.)

Keansburg Fire Company No. 1 was organized on October 3, 1912, at MacDonald's Raritan Bay Hotel, and William L. MacDonald was selected as the first chief. Their firehouse, built on Oak Street (now Manning Place) was initially a modest structure about the width of the door at right. Its expansion, beginning in 1956, made it a modern facility and its early origin is now no longer discernible.

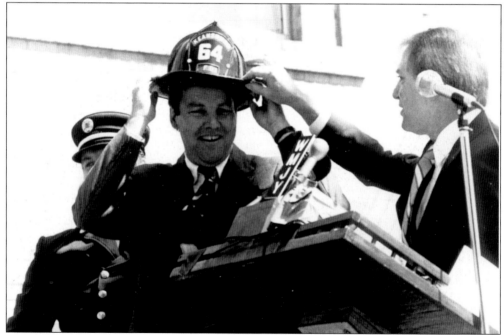

Governor Thomas H. Kean, a great-nephew of the borough's namesake, was in town on July 26, 1984, to sign a bill giving the borough $95,000 toward the purchase of much-needed fire-fighting equipment. While trying on a fireman's hat, Kean's arm obscured the face of Keansburg Fire Chief John Feehan.

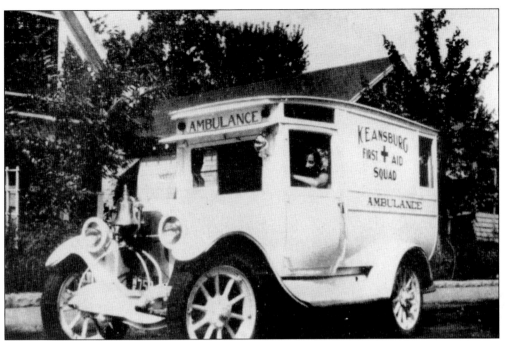

The Keansburg First Aid Squad was organized on April 6, 1932, and incorporated the following month, headquartered in the firehouse on Manning Place. The squad's first piece of equipment was this Chandler Ambulance, purchased from the Eatontown First Aid Squad and placed in service in December 1932. It was replaced in 1936 by a Cadillac, the squad's first new piece of equipment, which was paid for by a $3,000 fund-raising campaign. (Borough of Keansburg.)

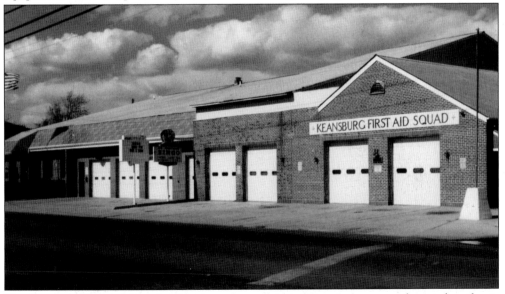

The first part of the public safety block on the east side of Carr Avenue was the two-bay, front-gabled section of the Keansburg First Aid Squad building designed by Albert Hunter, which was dedicated in December 1948 and later expanded. The New Point Comfort Volunteer Fire Company building at left was designed by Frederick Fessler of Hazlet and built in 1957, replacing the Oak Street firehouse.

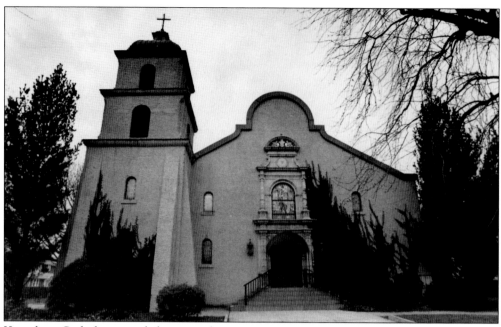

Keansburg Catholics attended mass at the Raritan Bay Hotel by 1912 and began to raise funds for a church by 1913. St. Ann's was built by local contractor Benjamin W. Covert at the northwest corner of Carr Avenue and Frances Place of stucco-clad, hollow tile. The Spanish Mission Revival-style church, reportedly designed by William P. Enderbrook of Trenton, has a three-story bell tower. The cornerstone was laid in August of that year, with ceremonies attracting a large crowd. (Photograph by Scott Longfield.)

St. Ann's began as a mission of St. Mary's, New Monmouth, Middletown, under the supervision of its pastor, the Reverend John E. Murray, who was responsible for the successful fund-raising campaign. Mass was first celebrated in May 1917; the new church was dedicated that August. Ceremonies drew another large crowd, one admiring its distinctive, attractive design. St. Ann's was established as a separate parish in 1924. (Photograph by Scott Longfield.)

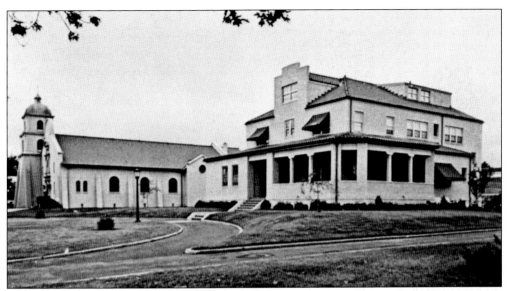

St. Ann's has changed since this c. 1970 postcard view was taken. The windows of the first two bays on the north are gone as this spot is the juncture of a wing connecting the church to the rectory, shown at right and built in the 1920s.

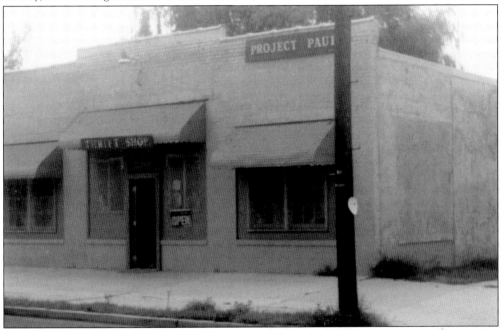

Project PAUL (an acronym for the Poor, Alienated, Unemployed, and Lonely that the group attempts to reach) was begun in 1979 by Fr. Strano in St. Ann's church as a food pantry/thrift shop. The church purchased this former commercial building at 211 Carr Avenue, installing a short-lived youth center, but had Project PAUL move there in October 1980 to house its operations, which include an expanded thrift shop that serves as a key fund-raiser. A second story was added in 1996, removing the building's 1920s commercial appearance. Project PAUL, serving as a voluntary, independent, homeless-prevention bureau, is organized as a 501 (c) 3 corporation, eligible to receive tax-deductible contributions.

The First United Methodist Church at 23 Church Street was founded in 1866 as the Granville Methodist Episcopal Church. The chapel was erected at 69 Church Street in a building that was later remodeled as a store. This edifice, seen in a c. 1905 postcard view, was built in 1895 and expanded several times. It was demolished; a new church built on the site was dedicated in 1972.

The Keansburg Pentecostal Church had its origins in the summer of 1957 at a storefront at 157 Main Street. The congregation purchased the Italian-American Club building on the northeast corner of Carr and Garfield Avenues in 1968, converting it into this church. Continued growth resulted in a major remodeling and expansion in 1989, as is reflected in this recent image.

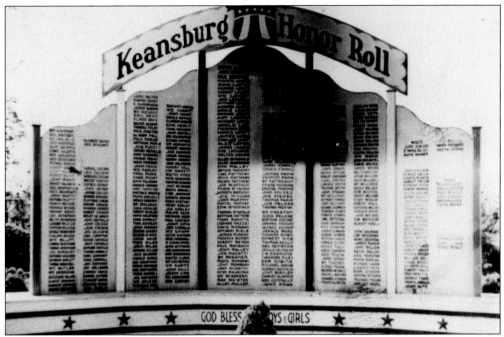

A World War II honor roll containing about 100 names was erected on the small triangular park at Carr and Garfield Avenues on July 4, 1942. It was repainted twice to reflect the growing participation of Keansburg residents in the war. An interim listing consisted of 290 names, while this, the final listing, contained 413. It remained until it was replaced by the permanent monument. (Borough of Keansburg.)

The Keansburg Lions Club erected this granite monument designed and built by the Long Branch Monument Company. It was dedicated on Saturday, August 28, 1948, with ceremonies including a parade and the raising of a flag that had flown over the Capitol. The monument lists over four hundred people who served, with the center panel honoring the following who died: William J. Albris, George Beaman Jr., Walter Chance, A. Harned Farrell, Arthur Fox, Patrick M. Grant, Marian J. Hart, Robert Kastner, George Major, John B. O'Reilly, James Overton, Vernon Papa, Walter Scott, Nelson C. Walling, and Raymond F. Walsh.

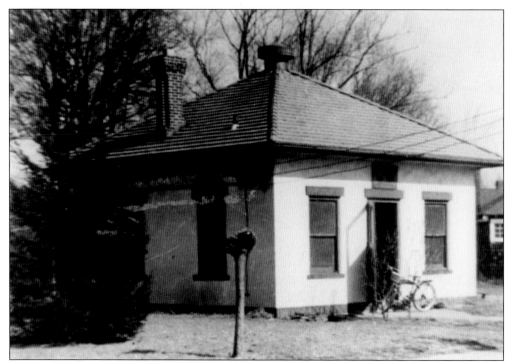

The former municipal sewage disposal plant, seen in a *c.* 1930 image, was built *c.* 1926 on the north side of Forest Avenue near Main Street. The state board of health demanded the inadequate system be replaced in 1938. A search for funding and lawsuits delayed its replacement, which was not begun until 1948. The new plant was built on the west side of Main Street, little more than 100 yards from the old plant. (Borough of Keansburg.)

The borough's history files indicate that a two-unit, coal-burning incinerator, shown here *c.* 1930s, was built in 1921. Both units operated in the peak summer season, but only the smaller one was used during the rest of the year. The stack was 50 feet high and was located in the marsh on the north side of Highway 36, west of Palmer Avenue. It operated into the 1950s; a small strip of stores is on the site now. (Borough of Keansburg.)

# *Five*

# Business

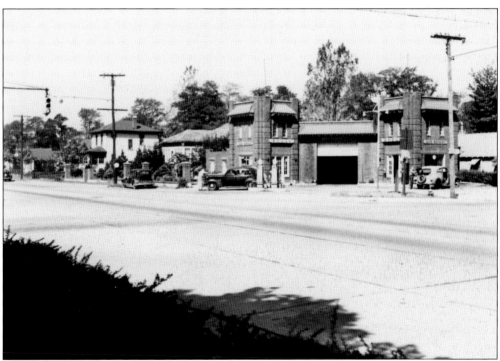

The Shell station at the northwest corner of Highway 36 and Palmer Avenue, seen here in a 1940s image, was probably built *c.* 1930s when oil companies were concerned with their respectability and positive contributions to roadside beauty. This location was long run by Val Miele and demolished after his death, the lay-out perhaps impaired by the widening of the highway. A modest structure is now on the site, its gas sales supplemented by the sale of convenience foods. (The Dorn's Collection.)

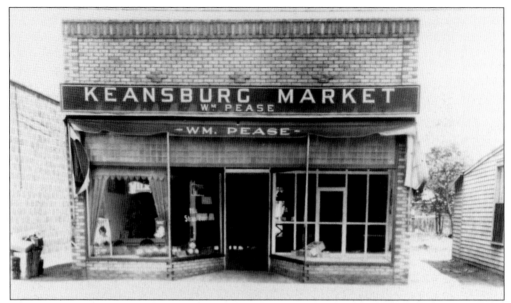

William Pease's Keansburg Market, apparently located at 204 Main Street, is believed to be the new store William Macdonald leased to Pease in 1912. The structure, seen here c. 1920, is now occupied by a sporting business with extensive changes having been made in the door and windows, but with existing brickwork that reveals the early structure. William was preceded in the business by George Pease, who sold to Keansburg residents from his Keyport store. George, "The Leading Cash Butcher," claimed to save consumers 2 to 5 cents on every pound. (Gehlhaus Archives.)

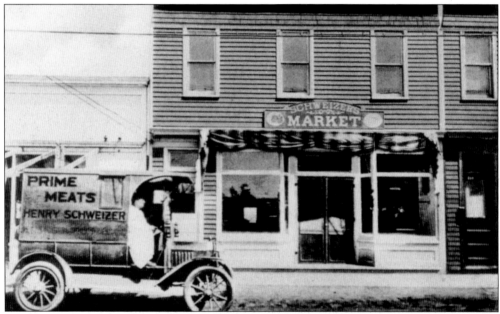

Henry Schweitzer called himself "The Keansburg Butcher," seeking an air of exclusivity. His store, seen in a c. 1920 postcard, appears to have been at 212 Main Street in a building now sided in yellow with changed doors and windows. The basic outlines of the original structure, however, are revealed through the changes. (Collection of John Rhody.)

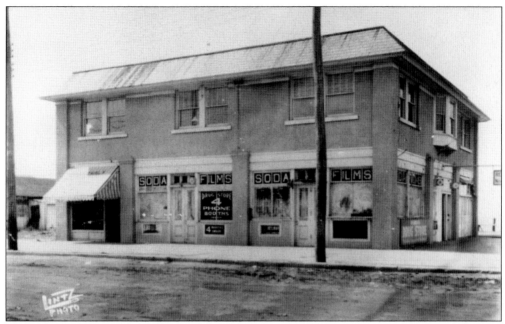

The former Rubens Drug Store on the north side of Beachway at the foot of Carr Avenue is little changed since this c. 1912 image and is readily recognizable today. Even the lavatory light is operated by pulling a chain from a ceiling fixture! The stucco-clad building preserves its rooflines and the second-story windows, including the bay, although the first-floor doors and windows are changed. A one-story extension is at left, or the west. The structure, long known as the "drug store building," houses the offices of the New Point Comfort Beach Company, the amusement park, and an eatery. (Gehlhaus Archives.)

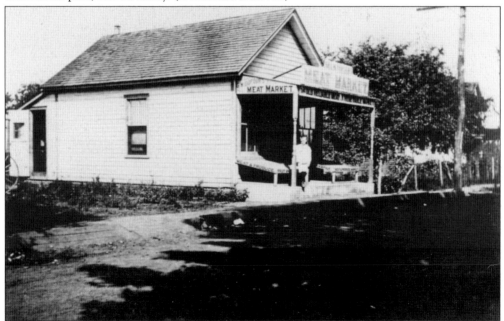

G.W. Dufour's old reliable meat and vegetable market was located on Main Street. In addition to choice meats and provisions, he carried poultry and game in season.

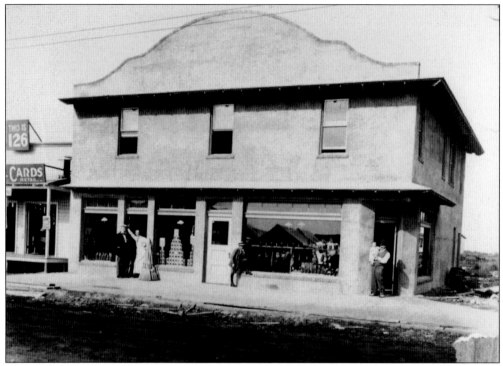

The Petterson Building, built *c.* 1910 on the northeast corner of Carr Avenue and Seabreeze Way, was distinguished by its Mission style roof parapet. Apartments were on the second floor. The place was later occupied by Harry the Butcher. (Gehlhaus Archives.)

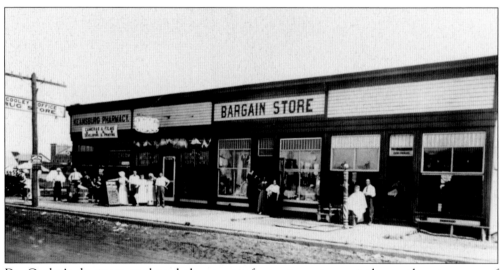

Dr. Cooley's drugstore anchored the group of one-story stores at the southwest corner of Beachway and Highland Avenue. One could get his hair trimmed outdoors on a sunny day and, if overexposed to light, retreat to the pool parlor at right. Runaway Rapids water park is on the site now. (Collection of John Rhody.)

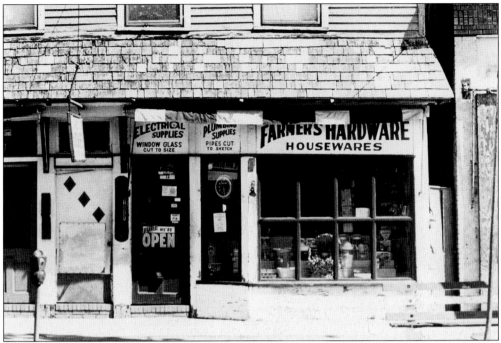

Tova Navarra, a talented writer, artist, and photographer whose *The New Jersey Shore: A Vanishing Splendor* is one of the state's outstanding photographic essays of our time, captured these Carr Avenue scenes during the 1980s project. Preferring the quietude of the off-season, she noted with regard to this picture that, "Farmers Exchange felt like an Edward Hopper—all talk and no action."

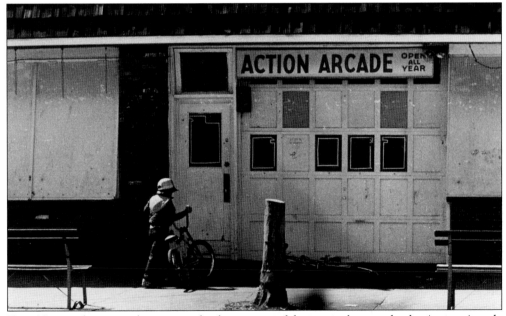

Tova Navarra has a searching eye with a keen sense of the ironic that caught the Action Arcade shut tight and denying the implication of its sign. The feeling was reinforced by the tree stump: neither life, nor action.

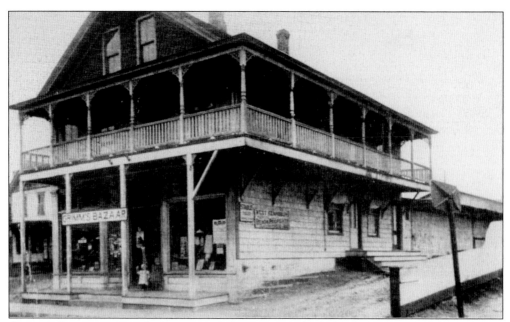

Grimm's Bazaar on Church Street, c. 1912, appears to be a dwelling converted for first-floor mercantile use as the business district in a growing town expanded. A grim place, indeed, although earlier it was the substantial Charles Carr general store.

The transition from horse to automobile usually resulted in former stables adapting themselves to serve the new, prevailing form of transportation. John Pockhart's Reliable Garage on the southern stem of Church Street presented a Keansburg example of this trend. (Borough of Keansburg.)

The W.A. Conroy and Sons Insurance Agency was founded in 1900 by Walter Conroy. His son Donald, seen here c. 1917, joined the firm in 1945. He is now retired, with the organization headed by James Patrick Conroy at its long-occupied office at 64 Church Street. Jim points out that theirs is one of the oldest family-operated agencies in the state.

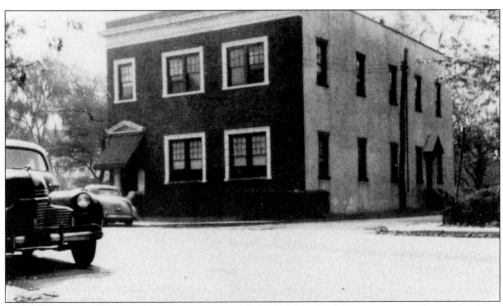

The New Jersey Bell Telephone Company still had "New York" in its name when it built its new Colonial Revival switching building at the southwest corner of Main and Locust Streets in 1925. It planned to change from a magneto- to a battery-powered system upon occupying the new facility. The property was given over as surplus by 1961; it had several uses before recent occupancy as the St. Ann's Child Care Center.

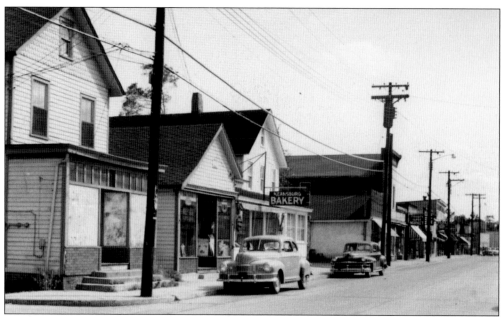

The portion of Main Street south of Lawrence Avenue has experienced reduced retail activity since this *c.* 1950 image. The former furniture store in the two-story building in the center is a bar; the bakery is gone, with a new frame ell attached to what appears to have been its former oven building in the rear. The two structures on the end are residences, the corner building now clad with shingles. (The Dorn's Collection.)

Collins Brothers opened a coal and wood yard adjacent to the freight depot as a branch of their main Port Monmouth facility. The latter was supplied by water, but the Keansburg yard was situated next to a railroad, reflecting changing freight patterns. The business is still located on the west side of Main Street between the former roadbeds of train and trolley, now selling masonry and landscape supplies and retaining only a minor interest in lumber. (The Dorn's Collection.)

The west side of Main Street north from Frances Place has been extensively changed since this c. 1950 image was made. Friendship Park is on the corner beyond the border of the picture, while the Main Street Manor condominiums are near the lot. The brick stores in the rear have sided fronts and are now residences. (The Dorn's Collection.)

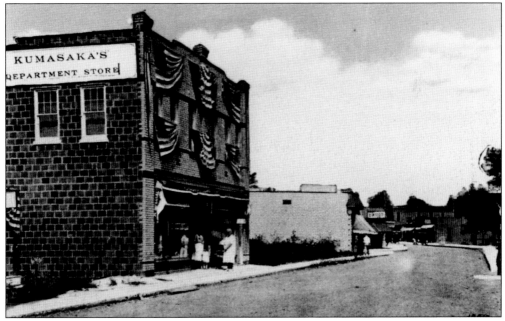

Archie Kumasaka opened a beachwear and gift store on Carr Avenue near the shore c. 1917. This substantial brick and tile building was erected in 1922 at 287 Main Street. The family-style department store carried a wide variety of goods, notably clothing, but not furniture. This 1920s postcard view looks north. Archie retired c. 1967, closing the business; the still-standing structure is occupied by a used furniture store.

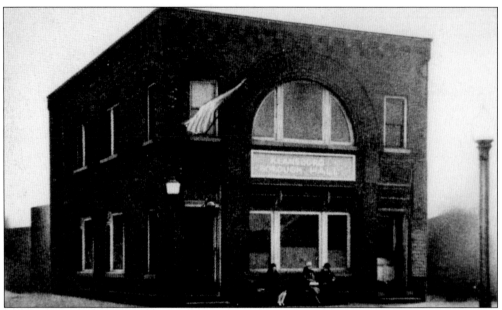

The Keansburg National Bank was organized in 1913. Key investors included Thomas W. Collins, William A. Gehlhaus, William L. Macdonald, Howard W. Roberts, and Charles R. Snyder. The bank erected this Romanesque Revival building the next year at the southwest corner of Carr Avenue and Church Street. It was designed by New York architect and Keansburg summer resident George Martin Huss. After the bank moved to the building pictured below, this one served as borough hall; it is now a luncheonette. The bank counters were removed and installed in the offices of the New Point Comfort Beach Company at the "drug store building," where they remain today.

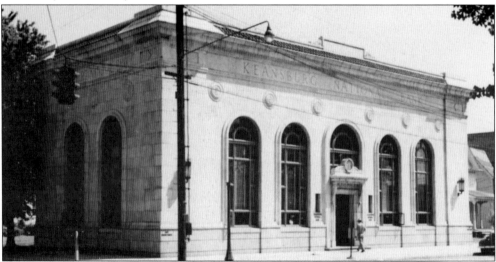

The new Keansburg National Bank at the northeast corner of Carr Avenue and Church Street was completed in 1928, designed in the Neo-Classical style by A. Stanley Miller of Brooklyn. Built at a time when banks utilized substantial structures to reflect their fiscal strength, it was and is one of the most impressive buildings in town. The bank's name and organization have changed in recent decades, most recently to that of CoreStates Bank. The borough's offices moved here, the town's new borough hall, in May 1997. (The Dorn's Collection.)

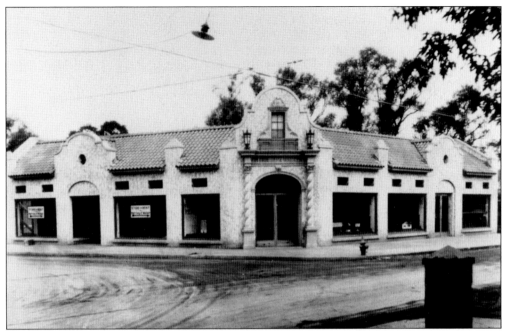

Morrissey & Walker, a leading Keansburg real estate firm and developer, built its offices on the northwest corner of Main and Church Streets *c.* 1920s. Compare the building's Spanish Mission Revival architectural style with that of St. Ann's Church (p. 82). The building was demolished for the erection of the Grandville Towers apartments. (Gehlhaus Archives.)

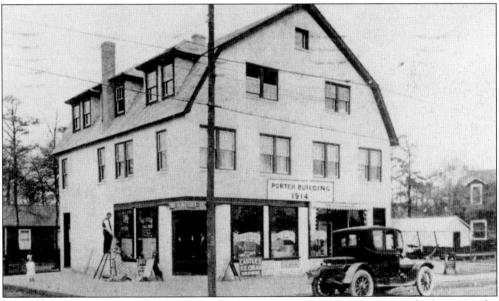

This two-and-a-half-story, hollow-tile and stucco store and rooming house was built in 1914 by George W. Rittenhouse & Son for James and Adelaide Porter on the northwest corner of Carr Avenue and West Shore Street; the plans were drawn by D.R. Rittenhouse. What was a "cider saloon" (a first floor occupant)? The upper story and dormers are gone, while the roof is now front-gabled. A Laundromat is on the ground floor; unchanged second-story windows confirm the old building is the one now standing. (Collection of John Rhody.)

The stores and apartments on the southeast corner of Main and Church Streets were built around 1955. This image from the final stages of construction is still recognizable; the grade floor is occupied by a variety of retail tenants. (The Dorn's Collection.)

A large brewer breeds and maintains traveling teams of eight Clydesdale horses for promotional and public-relations visits. The team was assembled with the 1933 gift of August A. Busch to his father to celebrate the end of Prohibition. The eight horses pulled a 4-ton brewery wagon. Note the Dalmatian mascot seated between the crew. At the time of this 1983 visit to Keansburg, the team was traveling about 45,000 miles annually, performing at least two hundred shows. Why Keansburg? They sell a lot of beer here.

## *Six*

# People and Places

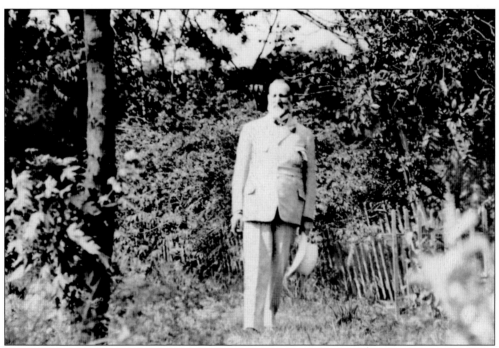

William Wilson Ramsay, born 1856 in Pennsylvania, trained as a Methodist minister and was assigned to Keansburg in that capacity in 1877, retiring two years later and entering business as a salesman in 1880. He opened a general store in Keansburg in 1884, the year prior to his election as freeholder from Raritan Township, continuing with the store to 1912. He was active in Republican politics, became Keansburg's first mayor, and was known by the honorific "Father of Keansburg." He married Eliza S. Wood, who survived him at his death in 1925. Ramsay is seen *c*. 1920s wearing his trademark flower in the buttonhole. (Borough of Keansburg.)

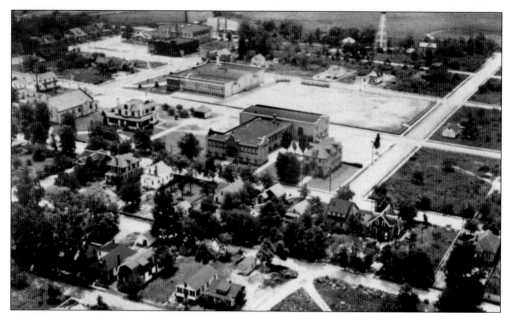

This 1940 aerial looking west from Main Street illustrates the St. Ann's complex and the Waycake lighthouse in their street contexts. St. Ann's (p. 82) runs diagonally across the center of the picture, with this view including the convent right of the school. The Frances Place School, above and to the left of St. Ann's School, shows the 1926 addition behind its 1922 four-room beginning. The photograph predates, of course, the 1949 one-story expansion on the north. (Borough of Keansburg.)

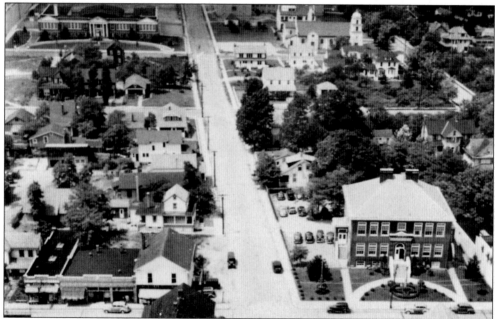

St. Ann's and the Frances Place School are seen from the south in a picture taken during the same August 1940 flight, this view taken over Church Street and Myrtle Avenue. The recently demolished borough hall is in the lower right corner (p. 75), its locale in the midst of an active shopping street. (Borough of Keansburg.)

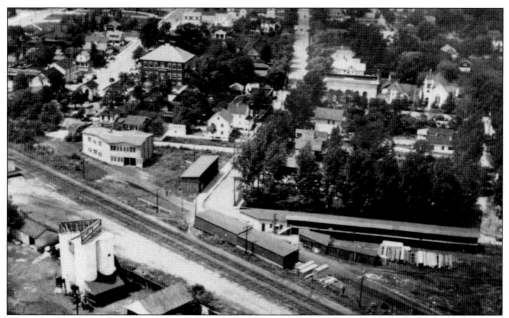

Carr Avenue looking north runs down the center of this 1940 aerial, while the former railroad tracks, now the Henry Hudson Trail, run diagonally in front. Six tall landmarks still stand. The Collins Brothers' storage tanks are south of the tracks, while a second lumberyard, Charles Englar's, is situated to the north. Their irregularly shaped two-and-a-half-story building remains, while a small strip shopping center occupies the spot of their storage sheds. The former borough hall (Church Street School, p. 75), the present borough hall (Keansburg National Bank, p. 96), and the former Methodist church (p. 84) are visible on the north side of Church Street, as is St. Ann's on Carr Avenue (p. 82). (Borough of Keansburg.)

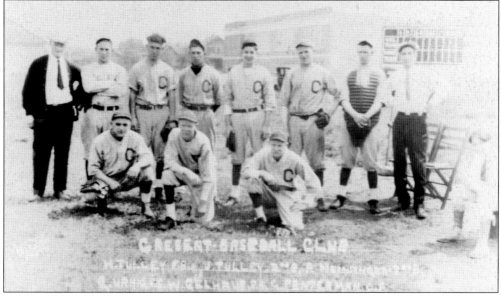

The Keansburg Crescents baseball club was associated with St. Ann's, recalled Paul Hunter, nephew of the team's manager, James Tully (at right). The team played at St. Ann's field, although this picture was taken at the rear of the Frances Place School.

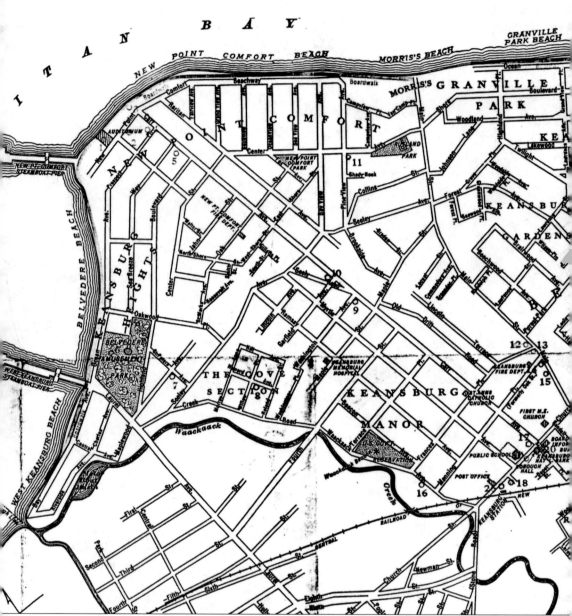

This map, dated 1925 and distributed by the Keansburg Board of Trade, is based on the 1917 map Frederick W. Moore drew for the new borough. The entire map embraces parts of Middletown Township at right and Hazlet Township south of Waycake Creek at left, which were not only in Keansburg's business sphere, but were considered for inclusion in the borough both prior to its formation and in later annexation issues. The section names originated with real estate developments, often formed from a single tract. Many were used with regularity in the past; some are now forgotten. The largest shaded area is the Belvedere Amusement Park, of which hardly a reminder remains. Both lighthouses were on sizable United States Government

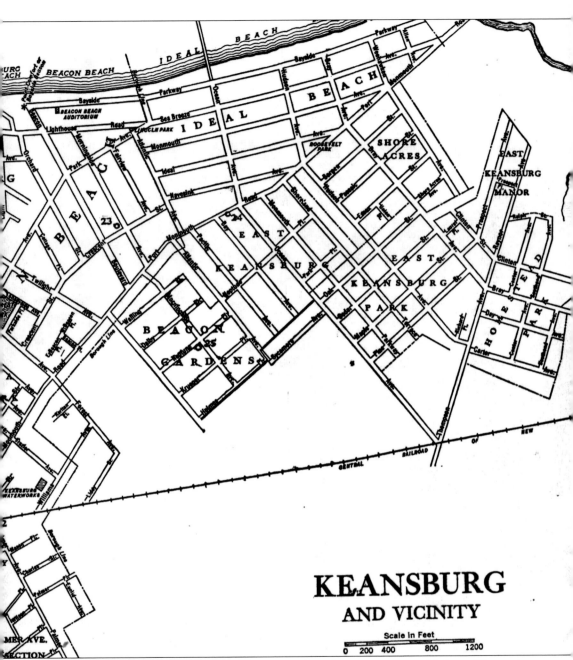

# KEANSBURG
## AND VICINITY

Scale in Feet

0   200   400        800        1200

Reservations, the subjects of territorial litigation after the government sold them. The major amusement district, New Point Comfort, is at top on the left. The early business district on Church Street by the tracks near the fold later expanded along Main Street. When viewing old references, it is helpful to know the historic names of two major streets. Main Street was the "Shore Road," with parts of it known as "Palmer Avenue," the present name of the section that runs through Middletown Township. Church Street, the eastern stem of the important connection to Keyport, was the "Stone Road."

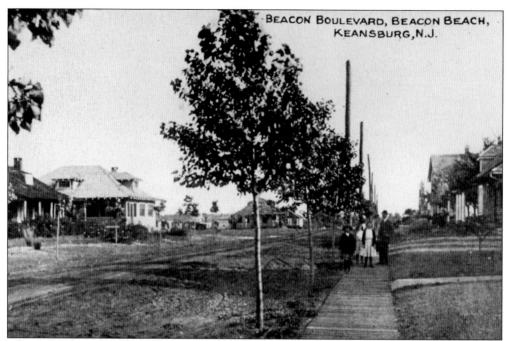

Beacon Boulevard, viewed in a c. 1912 postcard view, is a broad avenue running from Port Monmouth Road to the shore through the Keansburg Beach (later Beacon Beach) development. Beacon Beach's irregular plot had about a 450-foot frontage on the bay and extended to Main Street on the west, Port Monmouth Road on the south, and part of Keansburg's eastern border with Middletown Township. (Collection of Michael Steinhorn.)

Forest Avenue, seen in a c. 1910 postcard, was in the western end of Beacon Beach, part of a wooded area in which the developers planned a park for use by lot owners.

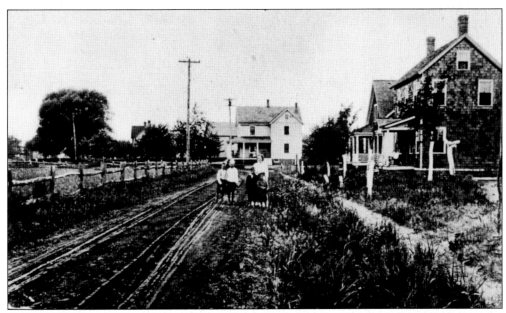

Seeley Avenue is seen looking west at its corner near Ramsay Avenue. The house at center, 151 Seeley, looks similar today to the image projected in this c. 1908 postcard view, although its chimneys are gone. The house in the right foreground has been replaced with a new one at number 141, while behind it is number 147, its porch now enclosed, but resembling this early image.

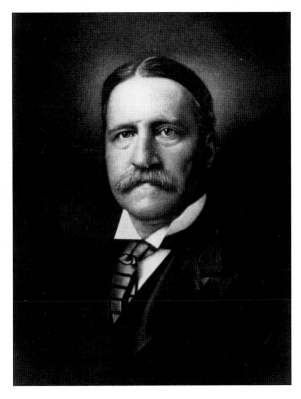

John Kean, the borough's namesake, born in 1852 near Elizabeth, New Jersey, was admitted to the bar in 1877. He was elected to the 48th Congress in 1883, was defeated for reelection, but was elected to the 50th. As Congressman Kean was helpful in securing postal services in 1884 for a town lacking an office since the one-year Granville office was closed in 1855, the grateful residents re-named the town as a gesture of appreciation. Kean, who also had banking and business interests, was elected to the United States Senate on January 25, 1899. He died in 1914.

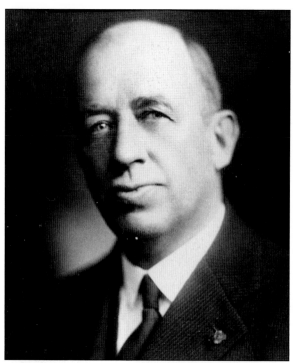

Paul C. Hunter, born in 1862, was an architect and engineer. Early in his career he was an architect for the Manhattan Railway Company and the Interborough Railway Company (subway) in New York. He was a partner in the Keansburg Heights Beach Company and designed a number of its buildings. Hunter enlisted in the army in World War I, despite his age, and served as an engineer in France, attaining the rank of major. His Keansburg holdings suffered in his absence, and He lost interest in them after the premature death of his wife in 1920. He sold to a partner around then and died in 1935.

Paul C. Hunter's first Keansburg house was built in Granville Park *c.* 1909 in the Colonial Revival style he favored. Nicknamed Hunters Roost, it is seen in a *c.* 1910 postcard. Hunter became a major investor in the Keansburg Heights Beach Company *c.* 1910, for which he designed two other Hunters Roosts. He retained this house at 120 Shore Boulevard until 1912, then traded it to Edward Downey for a lot on Main Street and a newly cut Palmer Place. This house still stands, its detailing obscured amidst yellow siding and the addition of two bay windows.

Lydia H.E. Straker married Paul C. Hunter on July 14, 1898. The Strakers were partners with the Hunters in the Keansburg Heights Beach Company, Lydia holding the office of president. Seen here *c.* 1899, she died in 1920.

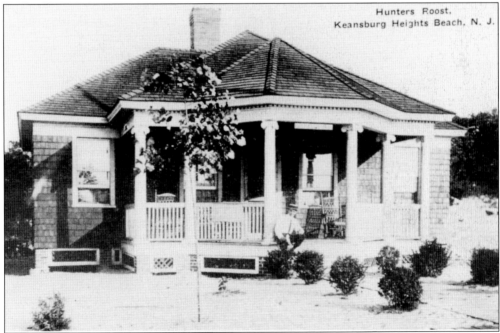

Paul C. Hunter was an officer and managing director of the Keansburg Heights Beach Company. He designed this house for his own use, having it built prior to 1910 at 62 Highland Boulevard on the development's tract west of New Point Comfort Beach. The Colonial Revival was soon moved to its present location at 77 Seabreeze Way to permit Hunter to build the house on the top of p. 108 on Highland. This one still stands with no visible changes.

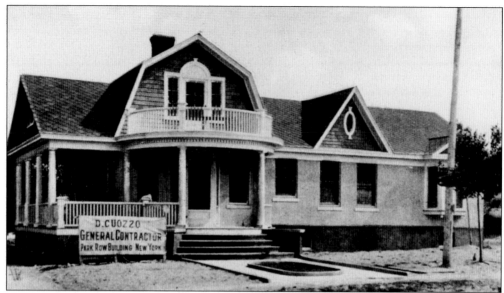

Paul C. Hunter designed this stucco-clad, Colonial Revival-style house for his use, the third Hunters Roost, building it in 1910 at 62 Highland Boulevard. It is well preserved, still in the Hunter family, and immediately recognizable, although the porch is enclosed and the second-story balustrade is gone, while a mature tree is in the ground opening at the entrance. Cuozzo expected to be remembered, as his nameplate is still securely imbedded in the pavement. (Collection of John Rhody.)

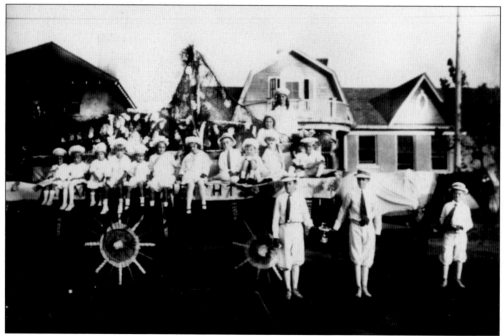

This c. 1915 image is a float in front of the house at top. Albert Hunter, father of Paul (the lender), is at right, and Paul Hunter (Albert's father) is standing in the center. Perhaps his holding a cup reflects the fact that he won a competition. Anna Hunter is sitting second from the right. Note the old ship's mast used as a flagpole.

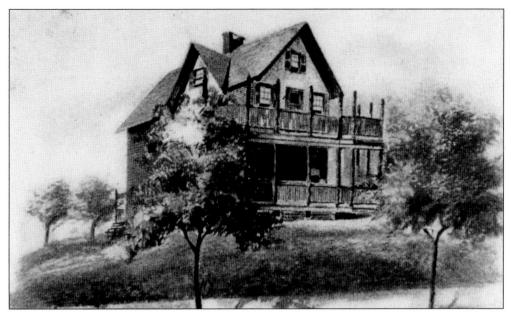

George Martin Huss, a New York architect born in 1853, studied at City College and in the architectural office of Vaux, Withers, and Radford. He owned and likely designed this house at 97 Park Avenue in the Keansburg Beach, later Beacon Beach, section. This view is a rendering on a 1907 postcard and the image appeared in the Keansburg Beach brochure in the same year; however, a news report indicated the house was built in 1911. It stands, radically altered and enlarged, with stone facing on its first floor and siding on the second. (Collection of John Rhody.)

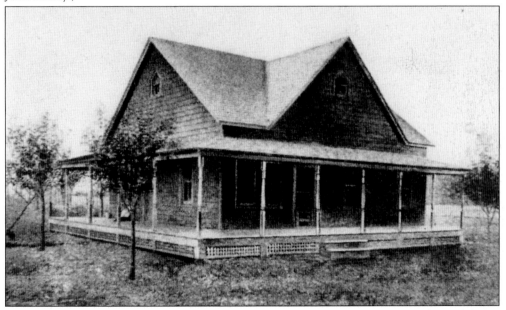

Frederick D.K. Turner bought the Gindele bungalow on Cottage Place in 1908 and remodeled it, changing the roof, adding two porches, and doubling its size. This c. 1910 postcard presumably pictures that place, although nothing comparable to this structure can be found on the street now. (Collection of John Rhody.)

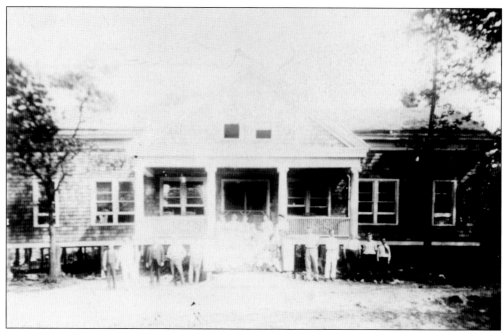

This *c.* 1909 image at the Granville Park Hunters Roost (p. 106) shows Paul C. Hunter standing second from the left. The figure at the bottom of the steps on the left may be his brother. Lydia is at top center, while Albert R. Hunter is next to her.

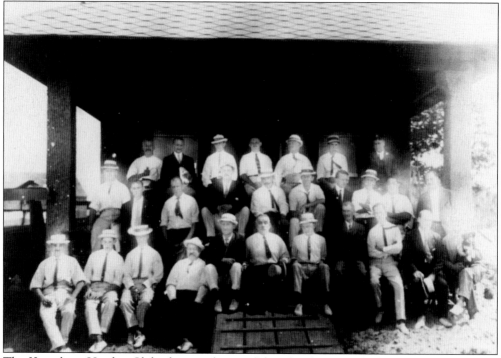

The Keansburg Heights Club, the social arm of that development, had a clubhouse near the beach. Paul C. Hunter is in the second row, third from the left, while the man with the puppy at the right is his friend, Rudolph Jiminez.

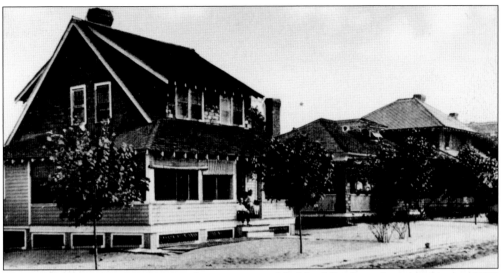

Three early Keansburg Heights Beach properties on Highland Boulevard, pictured in a c. 1908 postcard, are, from left to right, no. 56 (the Rosamond), no. 54 (Seniors Nook), and no. 52 (Wooloomooloo). Each was in the development's brochure advertising "The Red Roof Bungalow Colony Among the Trees." The houses are well preserved, although some changes have been made. The Rosamond, which still contains an open porch, now has siding; the Seniors Nook is now fully enclosed; and Wooloomooloo has an enclosed porch. The red roofs are gone, and these three are now covered by gray fiberglass shingles. Each of the houses could be duplicated for willing buyers, according to the brochure. (Collection of Michael Steinhorn.)

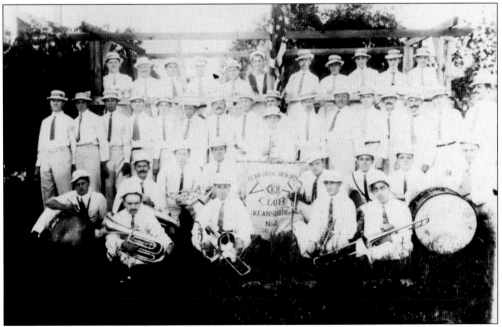

The Keansburg Heights Club band is seen c. 1914 after a parade. Paul C. Hunter is sixth from the left in the first standing row, and Albert Straker is eighth in the same row. Varley Straker, step-uncle of Paul C. Hunter (the son), holds the cup in back of the banner. Rudolph Jiminez is at far right, sporting a mustache.

The marble lions at the Steppanski-run boarding house at 27 Orchard Street should be familiar. They are now at the World War II memorial. The building, now a private residence, was extensively damaged by fire in 1937 but was rebuilt faithful to the original, the only differences being that the windows are changed and the house is sided in lieu of shingled.

Eileen M. Lloyd, elected to the three-person borough council in 1973, was selected as Keansburg's first woman mayor. Timing was not propitious for tenure, as Mrs. Lloyd did not run for office when a new style, five-person borough council-manager government was installed in 1974. However, she won election to the new council in 1975. Formerly employed in her husband William's Keansburg law office, Mrs. Lloyd is now retired, living in Florida.

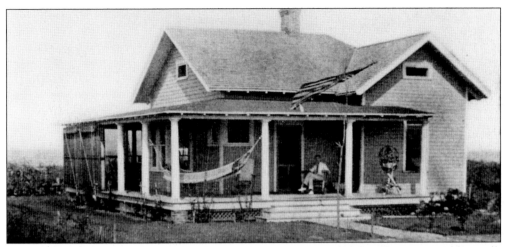

Keansburg Beach, located on the town's eastern shore, was developed c. 1912. This small, L-shaped cabin is expanded by a generous porch; the hammock and rockers reflect its usable living space.

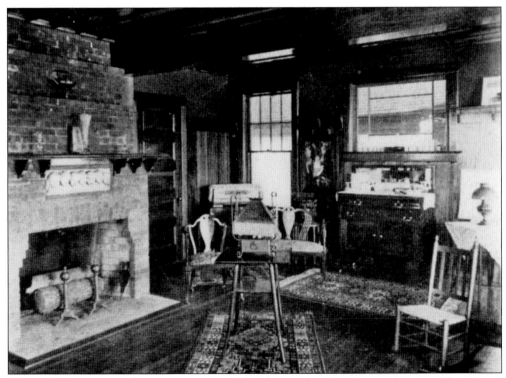

This c. 1915 interior reflects rustic country life in a compact, yet attractive, space. This picture and the one of the cabin above are from a Keansburg Beach Realty Company brochure.

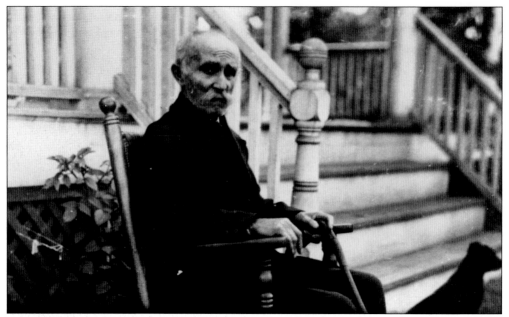

John Oliver (formerly Niklus) Broander, born c. 1842 in Sweden, emigrated to America as a young man, settling in Keansburg in the late 1870s after residing in New York. He had a long maritime career, rising from cabin boy to master and later specializing in oystering. John married Mary Manchester in 1879 and died in 1917, survived by his widow and ten children.

Mary Louise Broander, born 1881, was the eldest of John and Mary Broander's children. She married Lisle Ward of Keyport, a government surveyor.

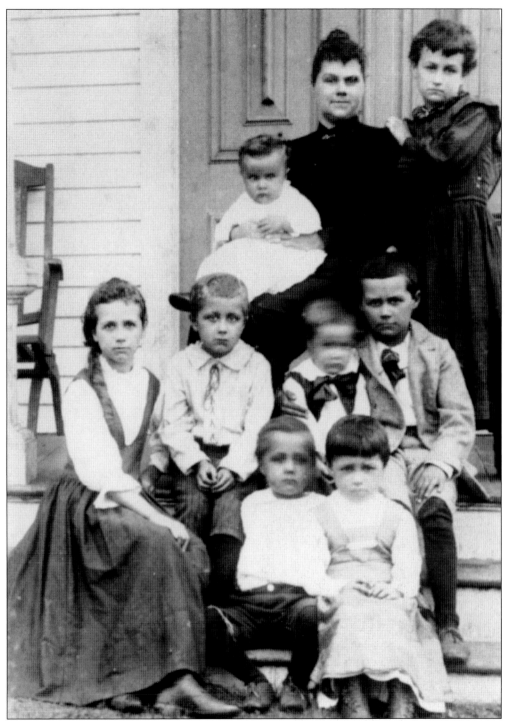

Mary Broander, wife of John, is seen in the early 1890s with eight of her ten children. She is holding Melvin Ramsay (known as Ramsay) while Caroline (known as Carrie) holds her mother's shoulder. From left to right, John and Arabelle are in the front row, while Louise, Stephen, Floyd, and Edward are in the center.

Millicent Broander and her sister, Beatrice Van Nortwick, seen in the early 1920s, are daughters of John Broander (Millicent's arm is around Beatrice). The sisters are active senior citizens today, and Millie lent generously from the family photograph archives.

It was Labor Day in 1915 and most of our unidentified young women are enjoying themselves, despite having to wear such long dresses. Why does the leader appear unhappy? Is she distressed because the one in the rear did not realize that white was the color of the day?

116

The American Motorcycle Association held its annual convention for 1931 in Keansburg on June 14. About fifteen hundred cyclists jammed the town for the event also known as their gypsy outing. Activities included various contests headed by a motorcycle race and a banquet at the Belvedere Beach Casino. (Borough of Keansburg.)

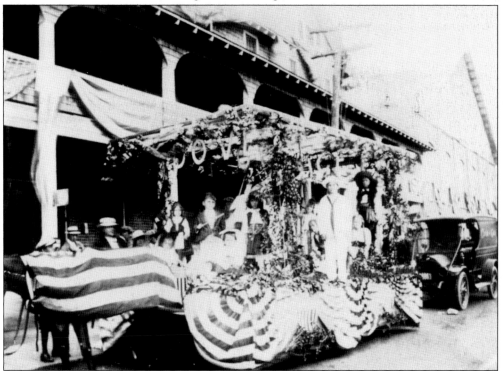

The Hunters' float was on Beachway *c.* 1916, in front of the New Point Comfort Hotel, for an unspecified celebration. Albert Hunter is wearing the Uncle Sam suit, while his sister Anna is sitting right of the sailor. The two were pulled by their mule, Maude.

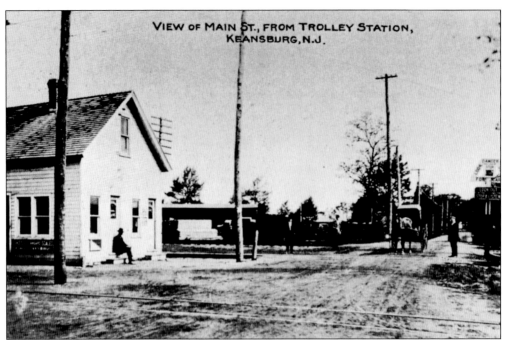

Main Street is viewed looking north in a *c.* 1910 postcard. The trolley tracks are in the foreground, while the Central Railroad's tracks are in front of the warning sign at right. The Collins Brothers' lumberyard was between the two tracks, while a second lumberyard is north of the rail yard. Collins is still in business, selling masonry and landscape supplies, but little lumber. Stores are on the part of the other yard that is near the street. (Collection of Michael Steinhorn.)

Main Street south of the Jersey Central Traction tracks *c.* 1912 was residential. Captain David P. Wilson's store and waiting room was on the west side of the street, now the site of an open field at the southwest corner with Wood Street. He sold candy and groceries; Wilson also checked parcels, bicycles, and baby carriages. He added the front section in 1910. (Collection of John Rhody.)

118

Samantha Patterson, age eleven, won first place in talent and modeling, two of three competitions in the 1984 All-American Calendar Girl Pageant. Her talent entry was a joke routine. Mrs. Patterson made costumes for her daughter, a pageant veteran who had entered over thirty-five by that time. She previously won the titles of "Miss Candy Kiss" and "Little Miss Ultimate Model."

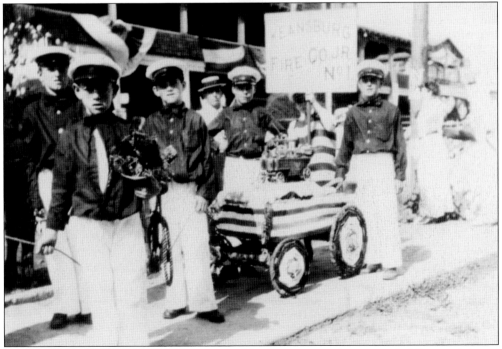

The Junior Boys of Keansburg Fire Company No. 1 are seen with a wagon holding a miniature fire apparatus, probably on Beachway after a c. 1915 carnival event. Perhaps they are winners, as the youth in front holds what appears to be a floral tribute.

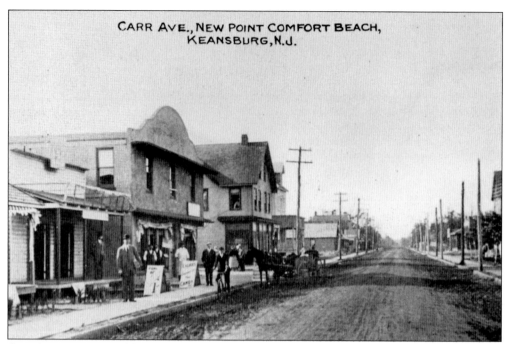

Carr Avenue is viewed looking south in front of Seabreeze Way around 1910. The Petterson Building at right, also on p. 90, no longer stands. The store on the opposite side of Seabreeze is now Nappy's General Store. Hotel construction would fill out these streets within a few years. (Collection of Michael Steinhorn.)

Carr Avenue, Keansburg's longest straight street, was developed by William A. Gehlhaus as part of his improvement of New Point Comfort Beach. This image from a 1906 postcard was also illustrated in the company's 1907 brochure. It is an "inland" stem, its exact spot not identified.

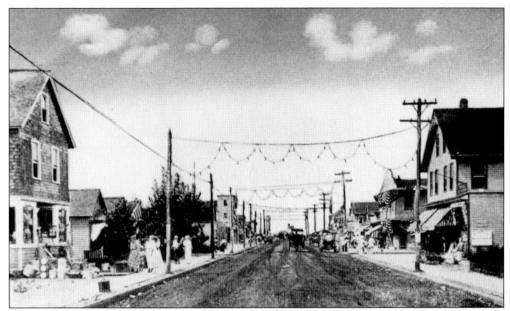

Carr Avenue, viewed looking north around 1915 from below Seabreeze Way, is filled with mercantile and residential buildings in the place of the hospitality and amusement facilities that would follow.

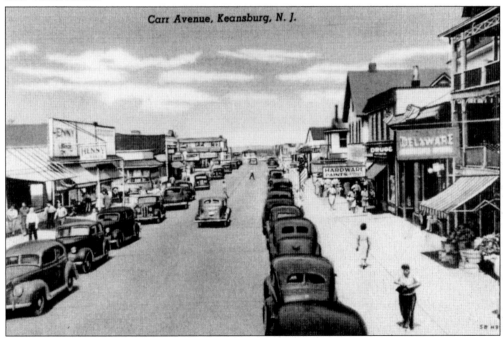

Carr Avenue, viewed from only a few steps south of the picture at top, was transformed over the twenty or so years between the image at the top of the page and this *c*. 1935 image. The street is paved and the sidewalks are widened. The one hotel visible, The Delaware, was destroyed by fire in the recent past. The front-gabled, two-and-a-half-story building at right, a constant in three Carr Avenue photographs, is Nappy's. Most of the low buildings on the west side of the street remain eating or amusement facilities. (Collection of John Rhody.)

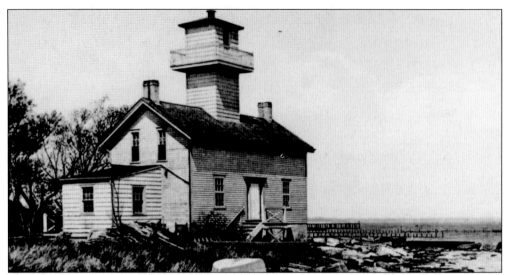

The Point Comfort, or Bayside Beach Beacon Lighthouse, also known as the beach beacon, was built c. 1854 on the Raritan Bay shore at what became the foot of Orchard Street. It burned kerosene oil during the nineteenth century, but changed to vapor gas in the early twentieth. Longtime keeper Thomas J. Compton, who lived here, indicated that it required considerable attention during the night to keep the light burning. Compton's wife, the former Experience Walling, served as his assistant. It was a lonely outpost, as Compton's closest neighbor c. 1865 was nearly two miles away. (Borough of Keansburg.)

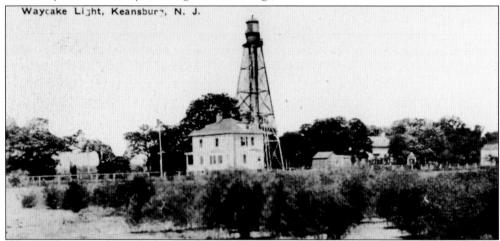

The Waycake Beacon was located on a triangular plot near Creek Road and Terrace Place. This plot and its beach counterpart were U.S. Government Reservations. The two beacons were range lights, which, when aligned, guided the mariner to what was then the main channel into New York Harbor, from inside the bar to Southwest Spit, per Nelson's *The New Jersey Coast in Three Centuries*. The first light, installed c. 1855 on property purchased from Andrew Wilson, was replaced in 1894 by another that had been displayed at the 1893 Colombian Exposition. Obtaining proper height was an on-going problem. The eventual 98-foot tower was "considerably higher" than its predecessor, but was "not high enough" per the December 19, 1896 *Monmouth Press* report. The tower's height had been 68 feet, with a total elevation of 78 feet, also per Nelson. The beacon's image is preserved in the borough's seal, but the tower was sold by the federal government for scrap in 1957. (Collection of Michael Steinhorn.)

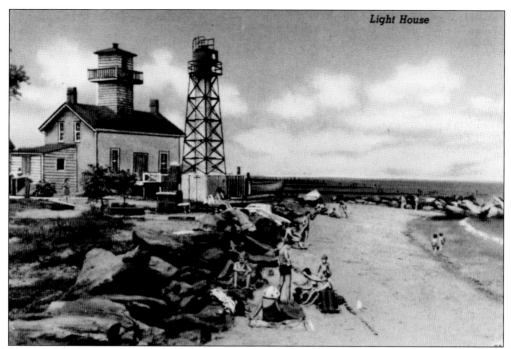

The light on the combined keeper's house with beacon tower was replaced at an undetermined date this century by this steel tower. The lights were decommissioned in 1940, when the tower was moved to Leonardo to replace the wood light tower that long served as the Conover Beach Beacon. The structure still stands at Leonardo, its survival a preservation concern as this book goes to press (1997). The keeper's house stood for many years, and is believed to have been destroyed by fire at an unspecified date. This image is from a *c.* 1930s postcard.

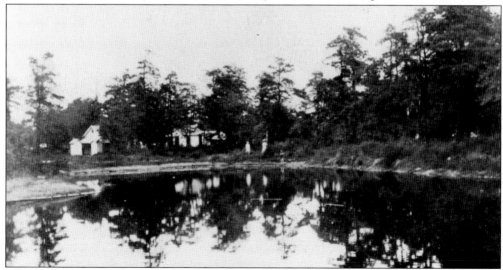

Lake Elsmere was located about in the middle of the block bounded by Carr Avenue, West Shore Street, North Shore Street, and Manning Place. The first New Point Comfort Fire Company firehouse was adjacent on Manning Place, built when that thoroughfare was named Oak Street. The lake was filled in 1912 and the land divided as building lots, with the site now covered by private residences. Try getting away with that today! (Borough of Keansburg.)

Anna Rossbach Meyer is seen in front of her still-standing home at 380 Palmer Avenue. Anna's only child, Carolyn, was photographed on Keansburg Beach in 1919. The girl, seemingly healthy and happy, unfortunately died the next year.

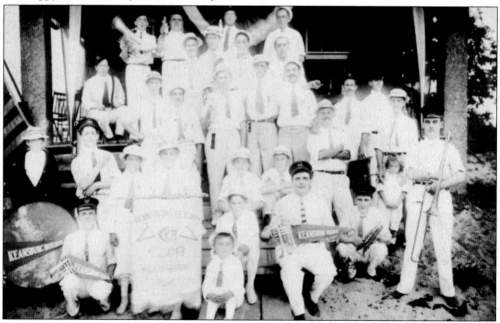

The members of the Keansburg Heights Club and band are seen *c.* 1915 in front of their clubhouse at Beachway. Paul C. Hunter is at top right, while his son Paul is at front right, holding the banner. Albert Straker is sitting in back of the cornetist, also with a banner.

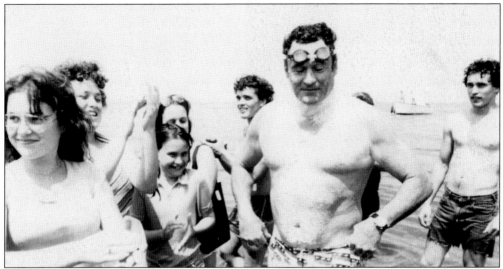

George Kauffmann took up distance swimming virtually as a lark, seeking an activity to use as a charitable fund-raising vehicle. He has swum around Manhattan Island nine times, at first to raise money for the American Cancer Society. It is a rigorous course that he failed to complete on three efforts. Kauffmann is seen emerging from the surf at Keansburg after a 1978 swim. A family throng greeted him, including wife, Ruthie. The couple is proud of their ten children, many of whom were also on hand and some of whom are pictured here.

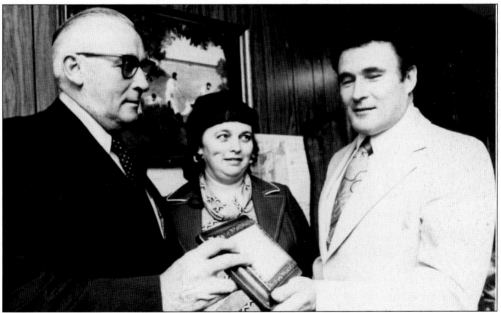

George E. Kauffmann Jr., a sixty-year resident of Keansburg, has held borough office since 1980 as councilman, deputy mayor, and mayor, an otherwise continuous tenure interrupted only by the one year he served as borough manager. Owner of the Centre Hotel Bar and Liquor Store, he has donated his councilman's salary to various charitable causes. George has received numerous humanitarian and man-of-the-year awards. He is seen in October 1977 at the right, receiving a plaque from Mayor Eugene Connelly honoring his 28-mile swim around Manhattan Island that September. Ruthie, his wife of over forty-three years, looks on.

125

John H. Fields, born in 1861, was a clammer who bruised his upper left arm in a maritime accident *c*. 1885. It failed to respond to treatment over a year's time, and his physician, Dr. Welch of Keyport, claimed that only skin grafts would prevent an amputation. A number of Keansburg children permitted small pieces of skin to be taken from their arms and grafted on Fields. Welch's operation was a success and the injury was forgotten. However, blood poisoning, perhaps dormant in his system for years, erupted in 1894, resulting in two operations. The arm was removed above the elbow and then at the shoulder. A year later the poisoning broke out anew, causing his death. John is shown with his wife, the former Eveline Covert, perhaps around the time of their 1884 marriage. The painting on glass of his arm is said to have circulated in the medical profession in a search for curative assistance.

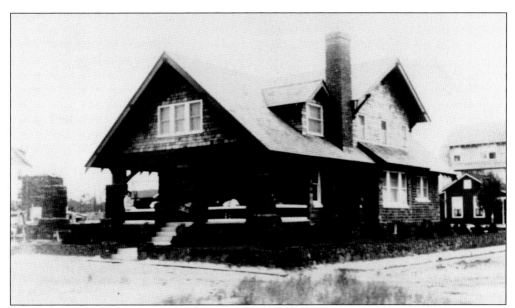

Luke McSherry, a New York fireman, bought the southeast corner of Beachway and Belleview Avenue in 1910. The land was adjacent to the eventual home lot of William A. Gehlhaus, who built houses for the two men c. 1915–20. The architect was likely L. Jerome Aimar, designer of the Gehlhaus dwelling. The two are both constructed in the Bungalow style, this one at 124 Beachway nicknamed Arbor Vitae. This image likely dates to c. 1917. The house is well preserved and little changed, although an additional gable is on the east side and a balcony was added c. 1970 in the front gable. Even the backyard planting reflects the times of the home's origin through a mulberry tree. (Gehlhaus Archives.)

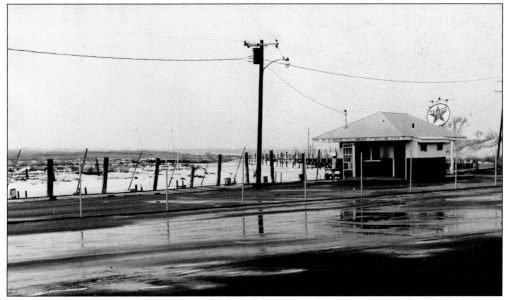

The Waackaak Marina is located at the foot of Charles Avenue on Keansburg's Waycake Creek border with Union Beach and Hazlet. The building in this 1968 image was replaced by a two-story frame structure. The flood control project was later built on a spot in the background that is obscured by the building.

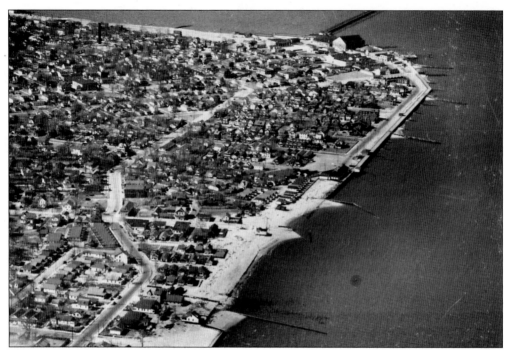

This 1951 aerial looking northwest shows the Keansburg shore from Granville Park on the bottom around to New Point Comfort at top right, with Waycake Creek located approximately at the top left. The old water tower and the steamboat pier are the two most discernible landmarks. The auditorium is readily recognizable to the right of the pier in the midst of the north side of the Beachway buildings. The rides are hardly visible; the largest, the Jack Rabbit (p. 25), was no longer standing. (The Dorn's Collection.)

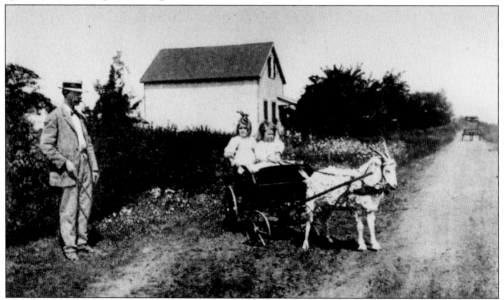

The c. 1910 postcard urged, "Just watch us go, Keansburg, NJ." Were there goat carts in Keansburg, or was this a generic card? In either event, it is the author's favorite ending. He hopes you enjoyed the ride. Keep the pictures coming for a prospective Volume II (see p. 8).